BUFFALO'S
SHORT LINE RAILROAD
— LEGACY —

MARK KLINGEL

America Through Time is an imprint of Fonthill Media LLC
www.through-time.com
office@through-time.com

Published by Arcadia Publishing by arrangement with Fonthill Media LLC
For all general information, please contact Arcadia Publishing:
Telephone: 843-853-2070
Fax: 843-853-0044
E-mail: sales@arcadiapublishing.com
For customer service and orders:
Toll-Free 1-888-313-2665

www.arcadiapublishing.com

First published 2022

Copyright © Mark Klingel 2022

ISBN 978-1-63499-441-5

All rights reserved. No part of this publication may be reproduced, stored
in a retrieval system or transmitted in any form or by any means, electronic,
mechanical, photocopying, recording or otherwise, without prior permission in
writing from Fonthill Media LLC

Typeset in Trade Gothic
Printed and bound in England

CONTENTS

Introduction **4**

1 Branch Line Neighbors: Buffalo Southern and New York & Lake Erie **6**

2 The Arcade & Attica: The Railroad That Time Forgot **37**

3 The Falls Road Railroad: The Erie Canal's Successor **58**

4 The Buffalo & Pittsburgh: The Modern BR&P **70**

5 The Depew, Lancaster & Western Railroad: GVT's Peanut Line **88**

Bibliography **96**

INTRODUCTION

During the 1970s, the American railroad scene was changing rapidly and the railroads found it difficult to adapt to the changes that were taking place. As a result of extensive government regulations, declining industrial business, and increasing competition from other modes of transportation, the freight railroad system of the United States was collapsing at an alarming rate. Even though passenger services were taken over by Amtrak beginning in 1971, many railroad companies around the country were still losing money with the idea of declaring bankruptcy looming on the horizon.

In order to save the railroad industry from total collapse, the United States government formed the Consolidated Rail Corporation, also known as Conrail, as a result of President Richard Nixon signing the Regional Rail Reorganization Act of 1973 into law. This act quickly adopted the name: the "3R Act." Not only did the 3R Act give birth to Conrail, it also helped form the United States Railway Association (USRA). Upon being signed into law, the USRA took over the powers of the Interstate Commerce Commission with respect to allowing the struggling and bankrupt railroads to abandon unprofitable railroad lines. The USRA was also tasked with drawing up a final system plan which would ultimately decide which rail lines would be included in Conrail.

When the final plan was unveiled in 1975, the following railroads would become assimilated into Conrail: Penn Central (Pennsylvania Railroad, New York Central, and New York, New Haven & Hartford Railroad), the Ann Arbor Railroad, Erie Lackawanna, Lehigh Valley, Reading Company, Central Railroad of New Jersey, Lehigh & Hudson River Railway, Pennsylvania-Reading Seashore Lines (merged 1976), and Monongahela Railway (merged 1993). As the years went on after the organization of Conrail, many

railroad lines from the assimilated railroads were sold off and abandoned as they were no longer considered to be profitable. These same rail lines would give birth to the short line railroads you see operating around Buffalo, New York, with some of them tracing their origins back to Conrail and the railroads that came before it. While some of the railroads mentioned in this book trace their history back to Conrail, others trace their heritage back to other larger or even smaller railroads.

Utilizing the Erie Lackawanna's Buffalo and Southwestern branch line to Buffalo, NY, the Buffalo Southern and the New York & Lake Erie Railroads operate various freight and passenger services between Buffalo and Gowanda, New York (Buffalo Southern) and Gowanda to Cherry Creek, New York (New York & Lake Erie). The Falls Road Railway services numerous agricultural, food, petrochem, and plastics industries along a former New York Central branch line that closely follows the historic Erie Canal. Operating between its namesake cities, the Genesee & Wyoming-owned Buffalo & Pittsburgh Railroad has established itself as a well-rounded class II regional railroad using tracks from multiple past railroads such as the Baltimore & Ohio, the Buffalo, Rochester & Pittsburgh Railroad, and the Pennsylvania Railroad.

The Depew, Lancaster & Western Railway's Batavia, NY, division provides the city's industries with rail service through a 4-mile-long industrial branch line and an interchange with CSX. On the Arcade & Attica, General Electric center cab diesel switchers have been teaming up to transport animal feed products and tourists between Arcade and North Java, New York, since 1947. The short line railroads of the Buffalo, NY, area and their predecessors have all experienced their own struggles and this is the story of how they got to where they are today.

1

BRANCH LINE NEIGHBORS:
Buffalo Southern and New York & Lake Erie

The Buffalo Southern Railroad is a class III short line railroad that operates revenue freight service and passenger excursion trains on the former Erie Lackawanna Buffalo & South Western branch between Buffalo and Gowanda, New York. The railroad began operations in 1982 after the lease agreement between Erie County and the neighboring New York & Lake Erie Railroad was not renewed. With the New York & Lake Erie Railroad having ceased operations north of Gowanda, the Erie County Industrial Development Agency began leasing the 32 miles of track between Buffalo and Gowanda to the newly formed Buffalo Southern. The railroad is also known to rail enthusiasts as being one of the many short line railroads in New York State that heavily relies on old Alco (American Locomotive Company) diesel locomotives. While the railroad keeps a variety of railroad equipment in storage in multiple sidings along their route, the railroad keeps a small active roster of Alco's to provide revenue freight service to their customers in western New York.

The Buffalo Southern, as well as the New York & Lake Erie Railroad, can trace the heritage of their tracks back to the middle of the 1800s with the charter of the New York & Lake Erie railroad by the legislature of New York in April 1832. The NY&LE was built as a broad-gauge (6-foot) railroad from Piermont-on-Hudson to Dunkirk, which spanned up to 446 miles of track. After years of financing and building, the railroad ran its first trip on the completed railroad on May 14, 1851. This became a major occasion with notable dignitaries riding as passengers. Such individuals included President Millard Fillmore, Secretary of State Daniel Webster, the attorney general, the postmaster general, and the secretary of the navy.

Gowanda, then in the town of Persia, needed stagecoaches and wagons to connect with the railroad until the Buffalo and Jamestown Railroad arrived in October 1874. The Buffalo and Jamestown was incorporated to build tracks out of South Buffalo and connect with the Atlantic & Great Western and the Erie Railroad. At this point in time, the Erie had finished its line from New Jersey to Lake Erie at Dunkirk and the New York Central was in the middle of building its system from New York to Buffalo and Chicago. Even though the rails were connected to the Atlantic & Great Western by 1873, a financial panic struck the railroad hard, which quickly forced them into bankruptcy. Following this financial panic, the railroad would later be reorganized as the Buffalo & Southwestern Railroad.

By 1881, Buffalo had become a major rail and shipping port in the eastern and great lakes regions. The Erie Railroad purchased the Buffalo & Southwestern in August of that year, which gave the Erie direct access to Buffalo. This branch crossed under the Erie's mainline to Dunkirk at Dayton via a stone arch tunnel that is still in use today with the modern New York & Lake Erie Railroad. Today, the Erie and B&SW tunnel is a popular attraction for rail enthusiasts and photographers who visit the New York & Lake Erie Railroad. While the B&SW tracks remain in active freight and excursion service, the Erie's mainline that the B&SW crossed under has been pulled up and abandoned for years. Leading into the 1920s, the Erie became Buffalo's third largest railroad serving the city and the surrounding communities. Passenger operations continued until 1952 with the last passenger train being powered by a lone doodlebug rail car. Despite the conclusion of passenger service in the 1950s, many of the stations remained open for service through the early 1970s under the management of the Erie Lackawanna Railway.

The Erie officially merged with its competitor, the Delaware, Lackawanna & Western Railroad in 1960. This merger would prove to become short-lived as service continued to diminish on the B&SW branch. Like its competitors in the east and Midwest, the Erie Lackawanna became negatively affected by the changes that were taking place in the American railroad industry. The final blow to the Erie Lackawanna's demise was dealt out when Hurricane Agnes slammed the southern tier of New York in 1972. As a result of the extensive hurricane damage, cost of repairs, and loss of revenue, the recently merged company was forced into bankruptcy and became one of many railroads that the United States federal government would band together to form Conrail.

Despite the idea that Conrail was formed to save the railroads, the numerous struggling branch lines would not share the same fate with the small levels of traffic they were receiving and B&SW branch was no exception. The branch line was abandoned when a deal was made to trade the B&SW to the city of Buffalo for a repayment of back taxes

that were owed by the Erie Lackawanna. However, due to the fact that Buffalo could not own the B&SW property since it was outside of the city's boundaries, the branch line ended up falling under the ownership of Erie County.

The Buffalo Southern serves its customers through their interchange point in Buffalo, NY at the south end of an old drawbridge spanning the Buffalo River known as "CP Draw." At CP Draw, Buffalo Southern can interchange freight traffic with a handful of class I and class II railroads such as Norfolk Southern, CSX, Canadian Pacific, Canadian National, and the Buffalo & Pittsburgh. CP Draw is a busy interchange point between these railroads with most of the rail traffic coming from either CSX or Norfolk Southern. At the south end of their small network, Buffalo Southern is also able to interchange freight traffic with the New York & Lake Erie in Gowanda, whose tracks extend to the small rural communities of Dayton, South Dayton, and Cherry Creek. However, Buffalo Southern has not interchanged freight traffic with the New York & Lake Erie in a long time.

While not easily accessible to rail enthusiasts in most areas, the action at CP Draw can be seen from the overpasses at Elk Street, South Park Avenue, and Tifft Street in Buffalo. Another way to get an up close and personal look at the action at CP Draw is to ride the Buffalo, Cattaraugus, and Jamestown Scenic Railroad's "Buffalo Rail Fan Train Ride" from Hamburg, NY, to CP Draw and return. Buffalo Southern offers a variety of services such as in plant contract switching, locomotive leasing, rail equipment storage, and locomotive and rail car repair. For example, the Buffalo, Cattaraugus & Jamestown Scenic Railroad, which charters BSOR diesel locomotives as well as steam locomotive Viscose Company No. 6, operates various passenger excursions on the BSOR's tracks between North Collins, Hamburg, and Buffalo. The Buffalo Southern's route starts at the interchange at CP Draw in Buffalo, NY, and continues southwest to Gowanda passing through the towns and communities of Blasdell, Lackawanna, Hamburg, Eden, North Collins, Lawton, and Collins. The old B&SW branch crosses over a diamond shared with the Norfolk Southern's Lake Erie District just south of CP Draw. The BSOR's main yard can be found in Hamburg where various pieces of old railroad equipment are stored in and out of public view depending on where you are in the city.

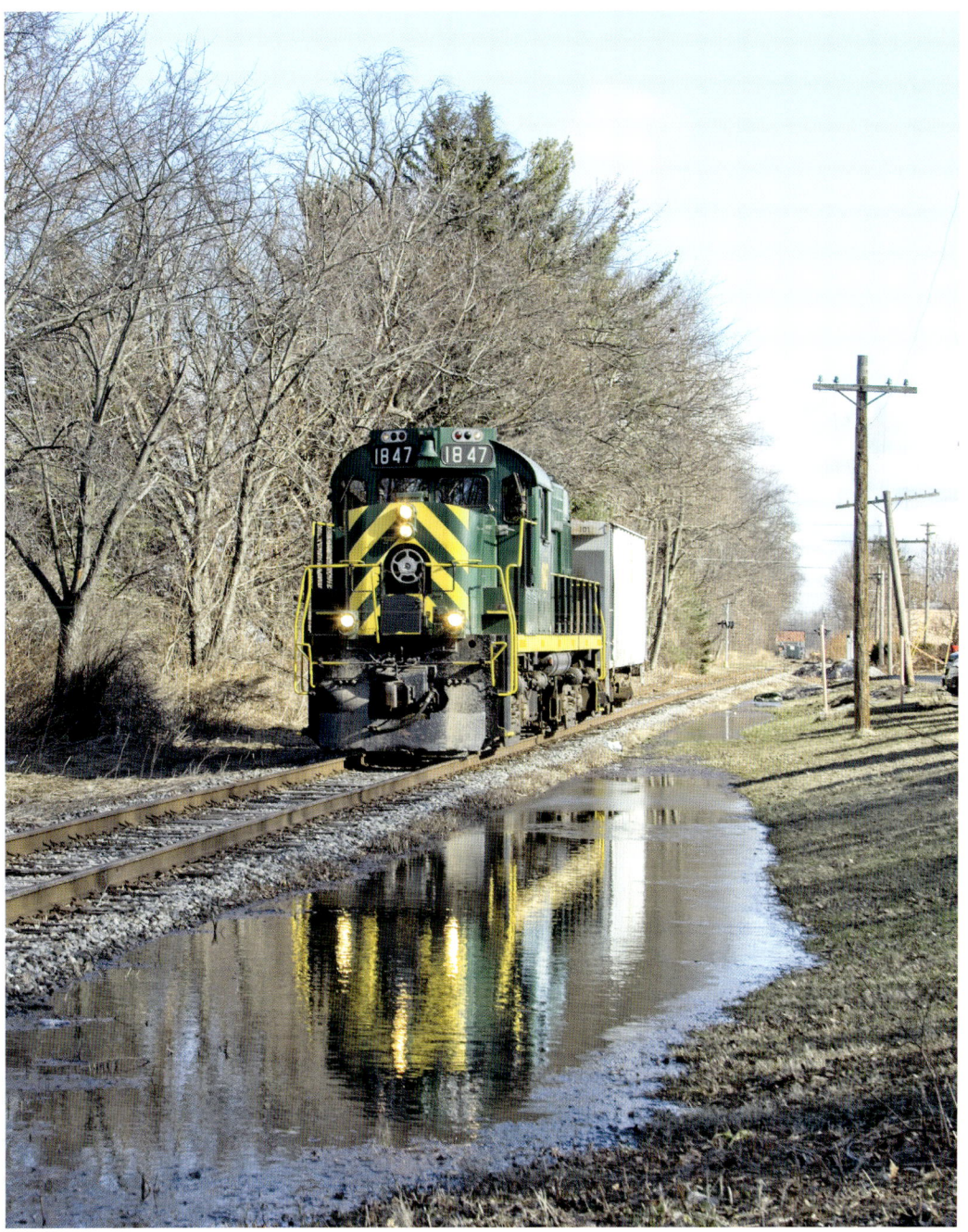

BSOR MLW RS-18 no. 1847 slowly rolls south out of the railroad's Hamburg yard with a buffer car in tow. The recent rainfall has allowed the reflection of the locomotive to appear in a large puddle next to the tracks.

BSOR 1847 crosses the steel bridge that spans over Eighteen Mile Creek.

Viscose Company 0-4-0T no. 6 waits to depart Hamburg with a Buffalo, Cattaraugus & Jamestown Scenic Railroad excursion.

Buffalo Creek no. 43, an ALCO Model HH660 switching locomotive, sits on outdoor display in a siding in Hamburg.

After collecting a line of loaded tank cars plus another buffer car in Hamburg, BSOR 1847 passes a local farm at the north end of Eden.

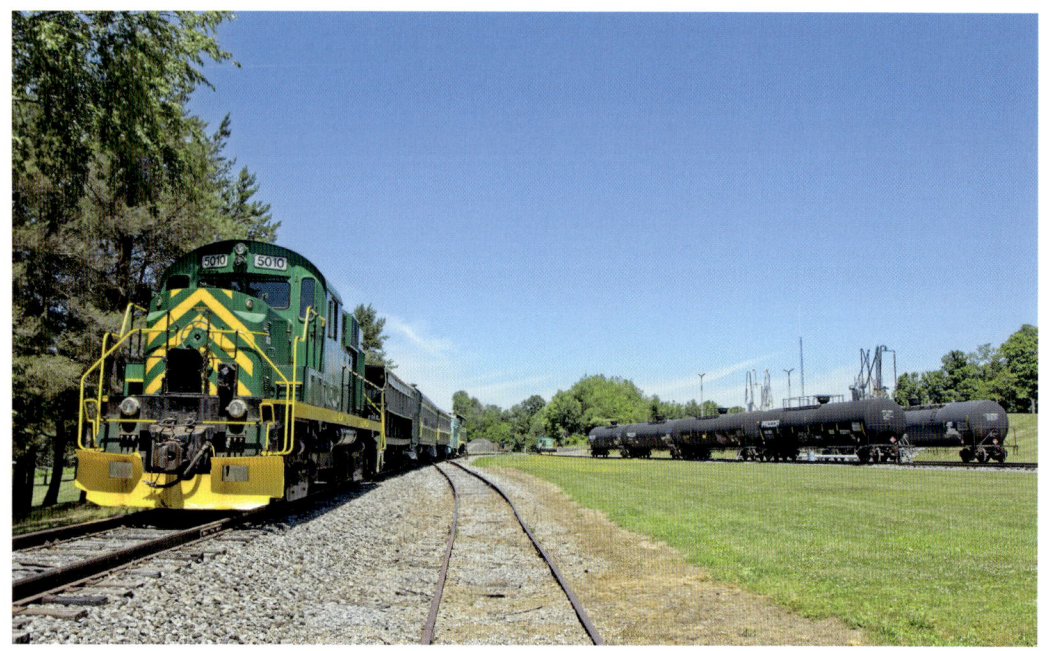

BSOR ALCO RS-11 no. 5010 crosses the Norfolk Southern diamond in Blasdell after working the railroad's interchange in Buffalo.

Niagara Energy, located in North Collins, is the Buffalo Southern Railroad's main customer. Tank cars filled with propane are frequently brought to the facility in North Collins from Buffalo using the tracks of the old Buffalo & Southwestern branch.

BSOR 1847 leads a train of empty tank cars from North Collins back to Hamburg.

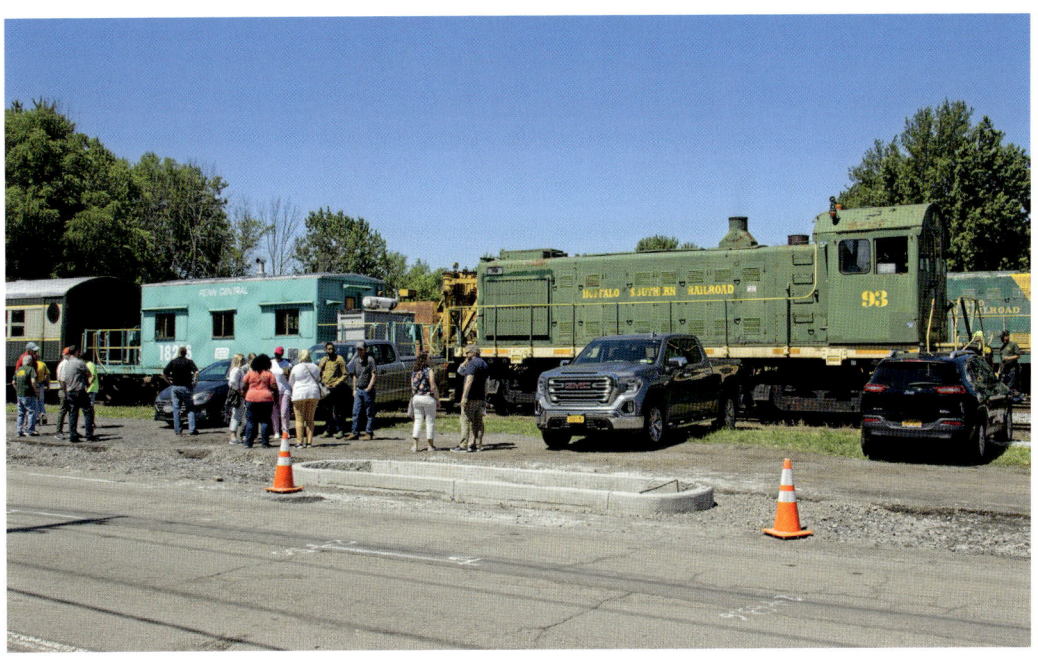

Bringing up the rear of the consist, no. 93 waits to depart Hamburg with a private excursion.

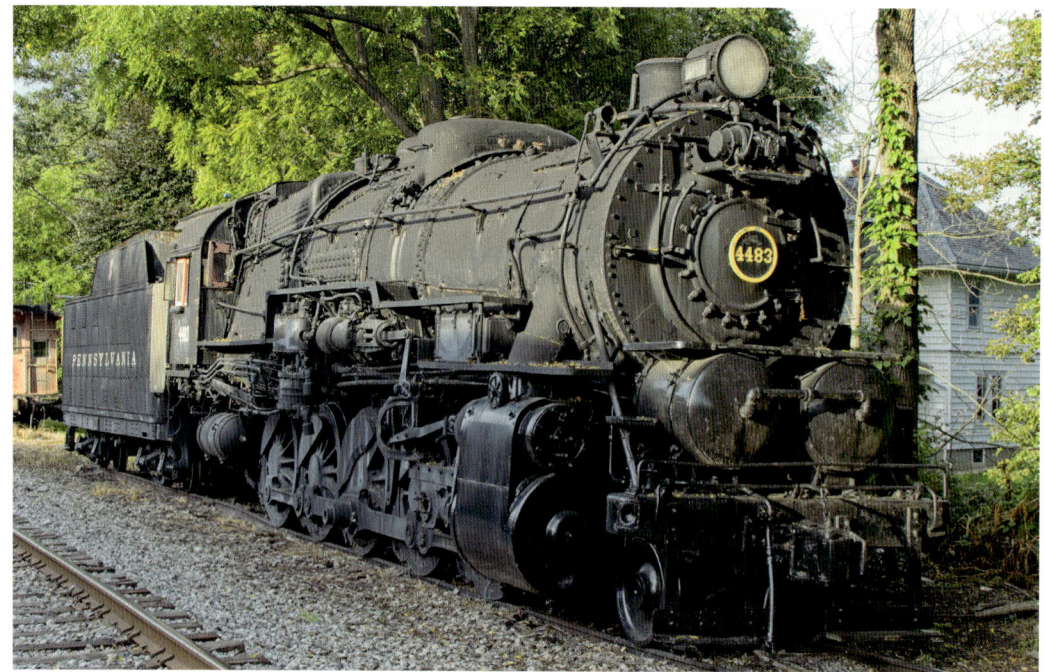

Pennsylvania Railroad I1 Decapod no. 4483 sits on static display in Hamburg. Built in 1923, 4483 is the sole survivor of the largest class of 2-10-0 steam locomotives ever built in the United States. After thirty-four years of service, 4483 was retired in 1957 and has remained on outdoor display under the ownership of the Western New York Railway Historical Society since 1982.

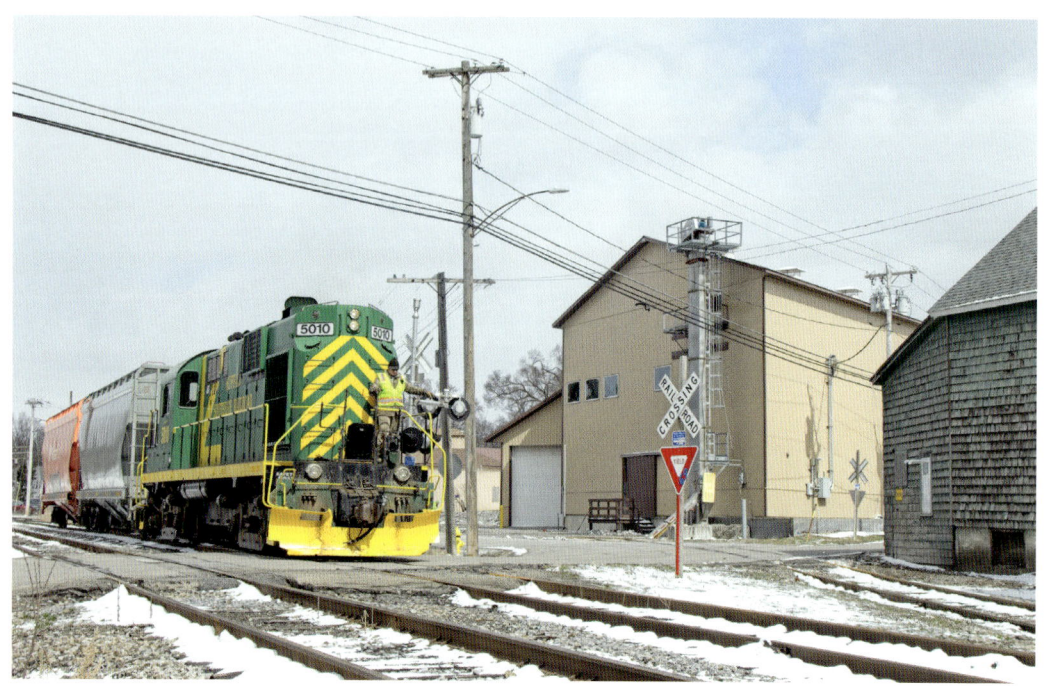

BSOR 5010 makes the first delivery of the 2022 season to Laing-Gro Fertilizers Inc.

BSOR 1847 powers a BC&J excursion northbound out of Hamburg.

BSOR 1847 rounds the curve outside of Eden with a line of loaded tank cars bound for North Collins in tow.

15

BSOR 1847 runs light to pick up a BC&J excursion that will be operating between Hamburg and Buffalo.

Operating for the first time in years, Buffalo Southern S-4 switcher no. 93 leads a special excursion northbound through North Collins. Compared to 5010 or 1847, no. 93 wears an older variation of the Buffalo Southern's paint scheme.

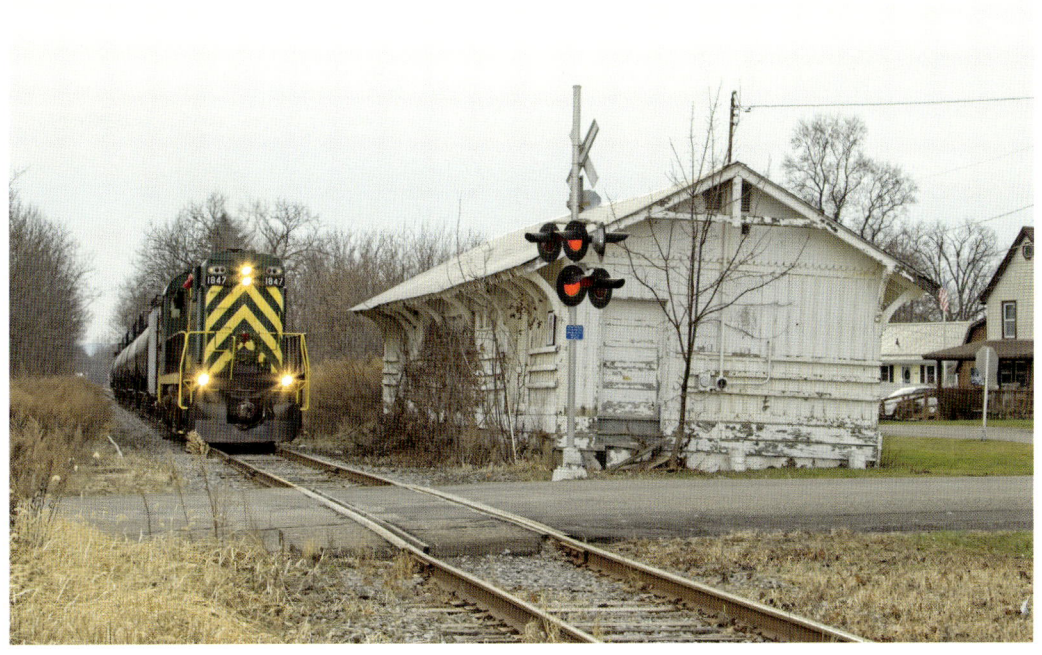

The route of the Buffalo Southern is littered with mileposts that date back to when the Erie Railroad was operating the right of way as the Buffalo & Southwestern branch.

As of 2022, the old depot in North Collins is still standing next to the crossing at Spruce Street.

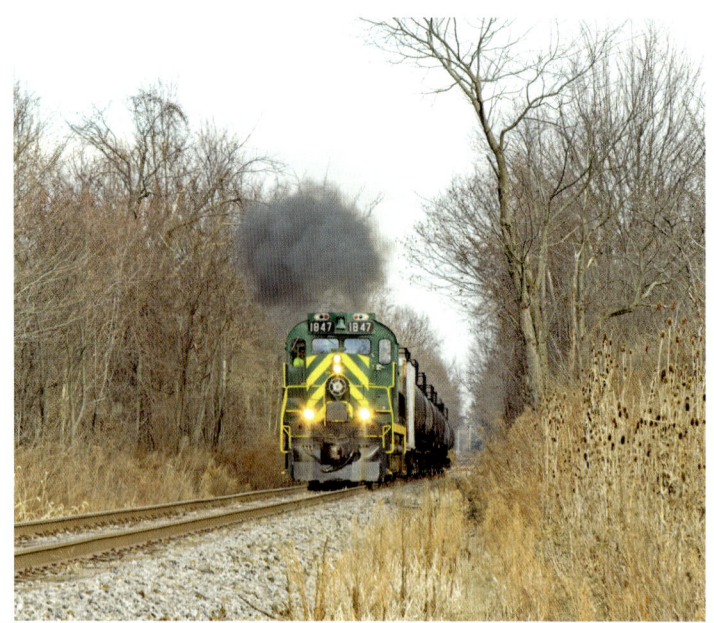

BSOR 1847 puts on a show of smoke and exhaust as the old diesel locomotive and its train approaches the village of North Collins.

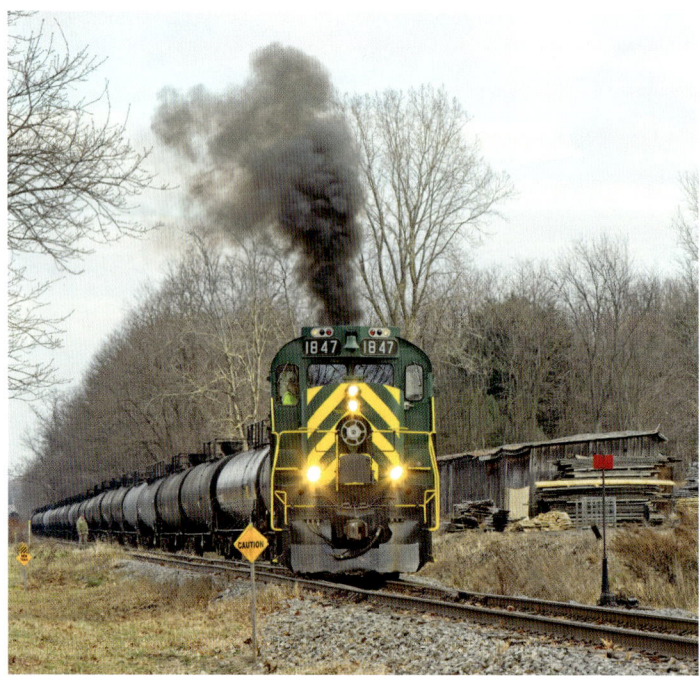

During the winter season, propane demand is at its peak for the Buffalo Southern. Due to this high demand for propane, deliveries to the refinery in North Collins quickly become a daily occurrence. Sometimes, loaded tank cars get put into storage in numerous sidings located between Hamburg and Eden. Here we see the 1847 pulling out a cut of loaded tank cars at New Jerusalem siding in Eden.

BSOR 5010 sets out two hopper cars filled with fertilizer at Laing-Gro Fertilizers Inc. The fertilizer is unloaded here in Eden and is distributed to customers in the surrounding areas that are a part of western New York.

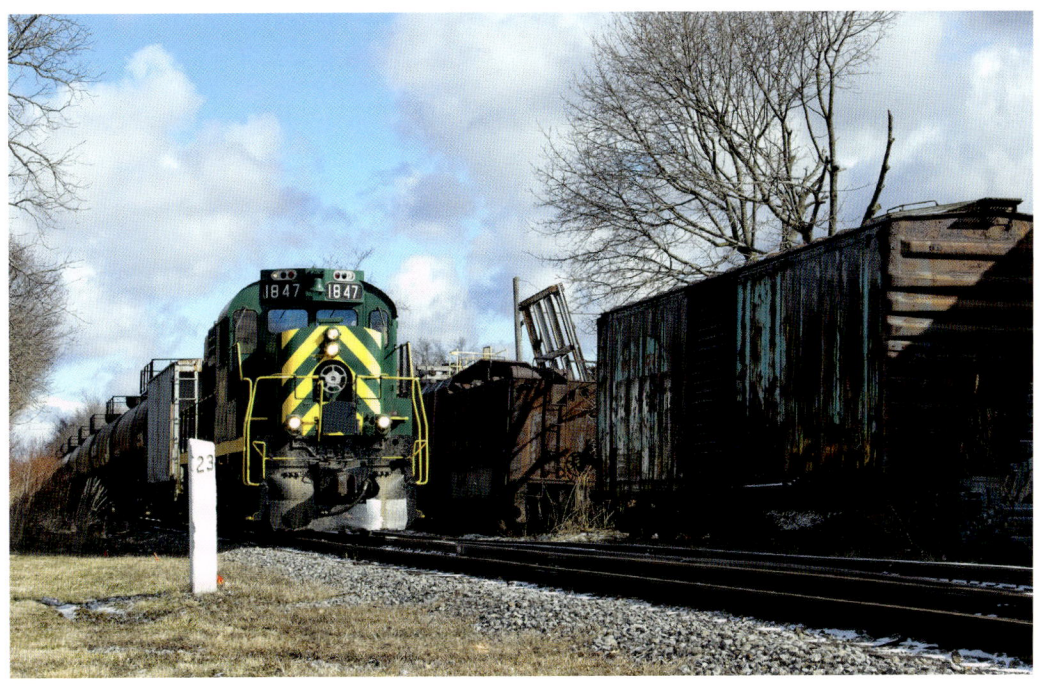

Entering the village of North Collins, BSOR 1847 passes by a small line of disused railroad equipment. Sitting in storage on the siding is a former New York Central boxcar and a large tender that once belonged to a Pennsylvania Railroad steam locomotive.

After completing the fertilizer delivery to Eden, BSOR 5010 passes by the Eden Center depot that once was the main office for the Buffalo Southern.

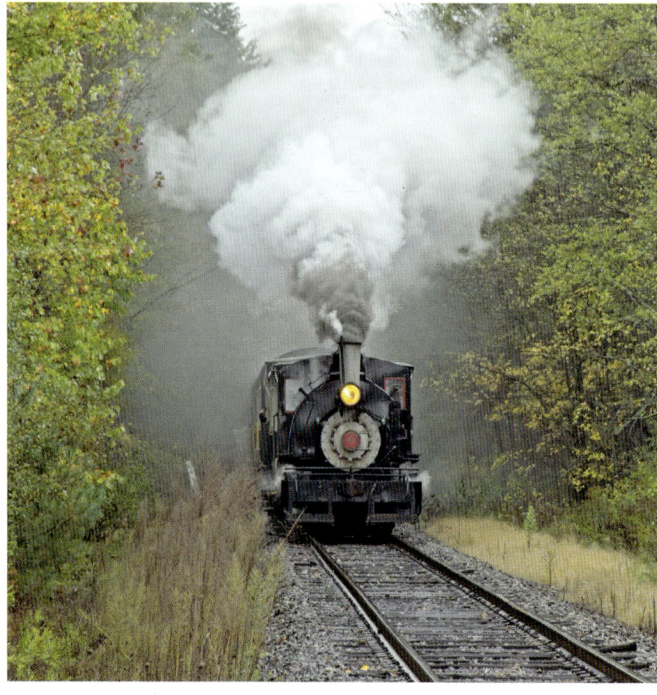

Viscose Company no. 6 powers its fall foliage excursion through the rainy weather outside of Hamburg.

While Viscose Company no. 6 waits to depart Hamburg with its passenger excursion train, Pennsylvania Railroad 4483 silently watches from the siding. As of 2022, no. 6 is the only operating steam locomotive in the state of New York.

Heading south to North Collins, the engineer slows the train down so the dispatcher and conductor can perform the routine orders hand off in Eden. A scene such as this is not commonly seen in the modern world.

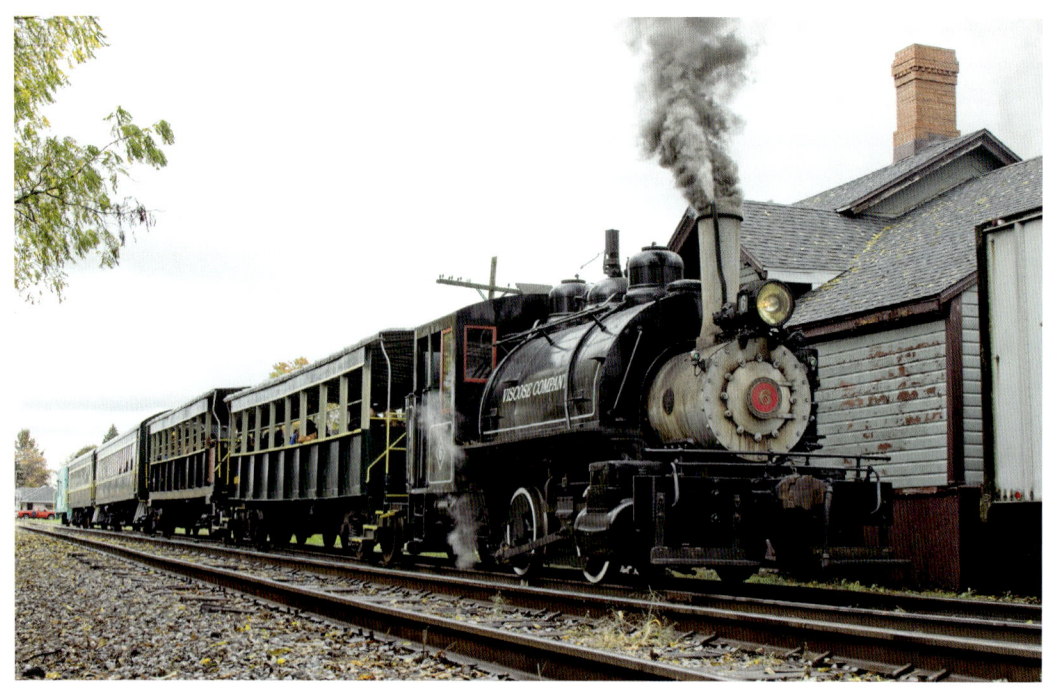

Viscose Company no. 6 is a 0-4-0T steam locomotive that was built by Baldwin Locomotive Works in 1924. It was purchased by Scott Symans of Dunkirk, New York, in 2004 and has operated on numerous railroads in the Midwest and eastern parts of the United States ever since.

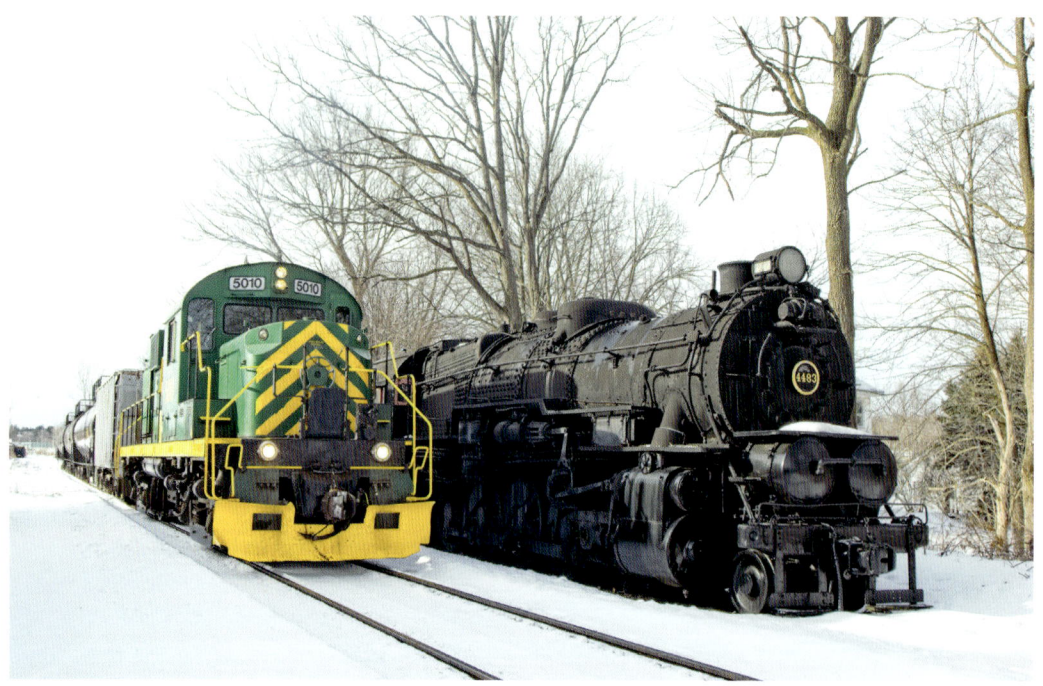

BSOR 5010 slowly eases its northbound freight train past the 4483 on a cold morning in February.

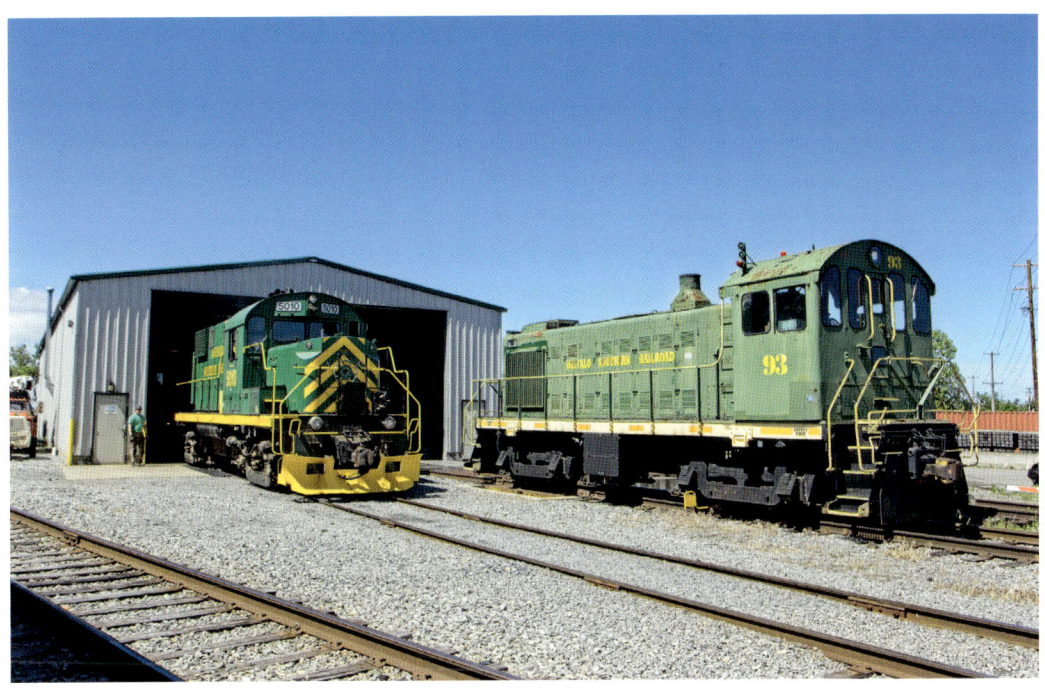

Preparing for a special private excursion, RS-11 no. 5010 exits Buffalo Southern's engine house in Hamburg while S-4 switcher no. 93 waits to begin the day's assignment.

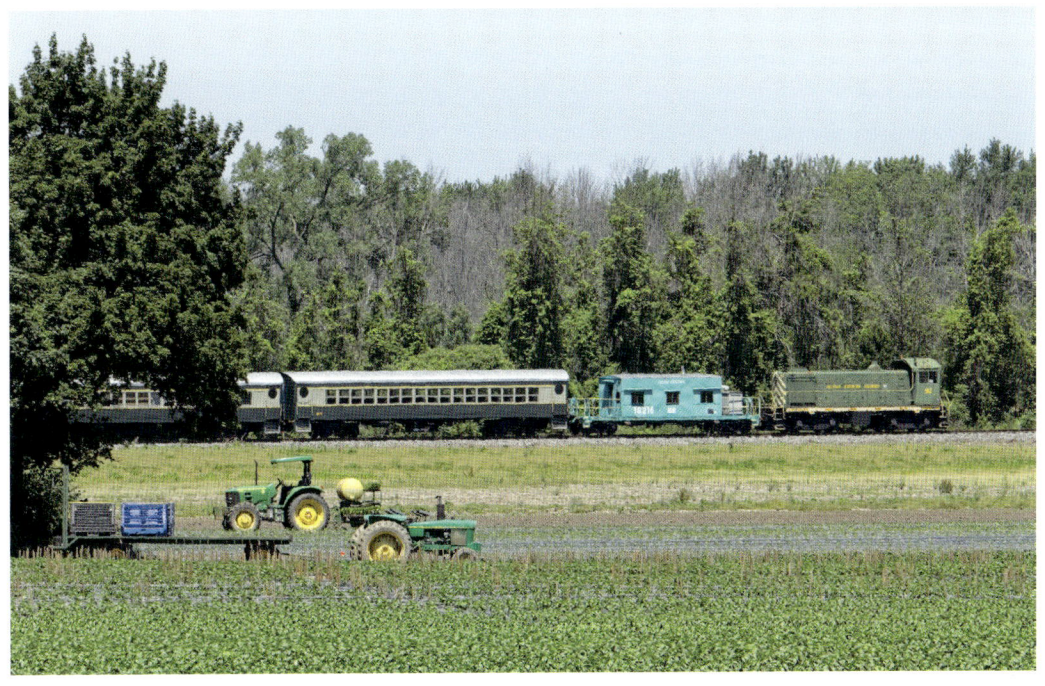

While a pair of John Deere tractors and some farm equipment bask in the hot afternoon sun, a Buffalo Southern excursion train passes by on its way south to North Collins.

Operating on the remaining southern portion of the Buffalo & Southwestern branch, the New York & Lake Erie Railroad has been providing passenger excursion and occasional revenue freight service to the communities of Gowanda, Dayton, South Dayton, and Cherry Creek, New York, since being organized in 1978. Like the Buffalo Southern, the New York & Lake Erie employs a small roster of Alco diesel locomotives. Despite not operating any steam locomotives, the railroad still maintains a loyal following from the surrounding communities with their passenger excursion trains between Gowanda and Cherry Creek. Despite freight traffic and local industrial customers disappearing on this portion of the B&SW branch over time, the NY&LE would make use of its tracks through interchanging and storing freight cars with the neighboring Buffalo Southern Railroad. However, as of 2022, the NY&LE has not stored any freight cars for a considerable amount of time.

The NY&LE's main branch once connected with the now-WNYP-owned Southern Tier Line in Waterboro before that portion of the line was decommissioned several years ago. Up until approximately the 1990s, the NY&LE also operated a branch between Dayton and Salamanca, NY, which also gave the railroad a second connection to the Southern Tier Line. By the early 2000s and 2010s, operations on this particular branch line would cease altogether when the portion south of the town of Cattaraugus was torn out to make way for the Pat McGee Trail and the northern portion had been significantly damaged by multiple floods and landslides. The flooding of the Cattaraugus Creek in 2009 caused the NY&LE to cease all passenger operations until late 2012 which made the railroad largely inactive for that period of time. Once necessary repairs were made to the line, the NY&LE resumed excursions between Gowanda and South Dayton with occasional runs to Cherry Creek.

The railroad, the South Dayton depot, and the town of South Dayton itself would get a taste of Hollywood stardom in the 1980s after being used as the setting for railroad scenes in *The Natural* (1984) and later *Planes, Trains and Automobiles* (1987). The locals of South Dayton are proud to say that they had Robert Redford walk the streets of their small town during the filming of *The Natural* in 1983. The baseball and carnival scenes were filmed just north of the South Dayton railroad depot, and a local farmhouse was used for a couple of scenes. During the few weeks that filming took place in South Dayton, the locals were able to participate in the filming by having many adults and children playing as extras in the movie. When Hollywood came to South Dayton in 1983, the town was transformed into a 1924 Nebraska town to serve as the backdrop for *The Natural*. One of the very first scenes of the movie was filmed in South Dayton during the summer of 1983 and was meant to cover the time when a young nineteen-year-old pitcher, Roy Hobbs, was on his way to Chicago for a big try out with the Chicago Cubs. While riding the train to Chicago, he meets the American League's leading hitter, "the Whammer." When their train

makes a brief stop near a carnival, Hobbs and the Whammer engage in a pitcher-batter showdown which ends with Hobbs striking out the Whammer with three pitches.

A few years later in 1987, John Candy and Steve Martin became the next celebrity actors to visit South Dayton and the NY&LE's depot for the filming of the comedy film, *Planes, Trains and Automobiles*. During February 1987, Hollywood came to Batavia and other communities in Erie and Cattaraugus counties, and to the people living in western and upstate New York, it was the biggest thing to hit the region in a while. The makers of the 1987 comedy film were looking for ideal locations that looked like the rural Midwest and with lots of snow. South Dayton was used to film the scene set in a Kansas town known as Stubbville. In the words of movie character Owen, "people train runs out of Stubbville." Despite the film crews looking for snow in their scenes, the snow they were looking for turned out to be uncooperative in the area they were filming. Natural snowfall ended up being a no show at the time, and the decision was made to have a snow making crew from Vermont be brought in to compensate. Later on during filming, the snow the film crew was looking for showed up at exactly the wrong moment. During the filming of a scene where a trooper pulls over Martin and Candy in their burned-out car, a squall quickly rolled in and delayed filming. Filming resumed once the storm passed, and a few months later on November 25, 1987, a holiday classic was born.

The New York & Lake Erie Railroad's route begins in Gowanda where the NY&LE meets with Buffalo Southern at the north side of the bridge that crosses the Cattaraugus Creek. The railroad's passenger depot, engine facility, and main yard reside on the south side of the Cattaraugus. Trains travel south of Gowanda uphill to Dayton through the western New York countryside before passing through the stone arch tunnel that allowed the B&SW to pass under the Erie Railroad's mainline that now sits torn up and abandoned. If you follow the right of way to the south side of Dayton's town limits, the old turnoff to the NY&LE's now defunct branch line to Cattaraugus can be found between Church Street and Gable Street. The tracks then continue south through South Dayton and end at Cherry Creek. South Dayton is the main layover and turnaround point for the railroad. However, some excursion trains can run the full length of the active rail line to Cherry Creek depending on what excursion train is scheduled. After running around their train, the NY&LE brings their passengers back north to Gowanda for the next excursion on their schedule. While the Buffalo & Southwestern branch is now a far cry from what it once was during the days of the Erie and the Erie Lackawanna, the Buffalo Southern, and the New York & Lake Erie together keep the old branch line alive by providing for the local economies by hauling freight and tourists on a branch line that was once no longer considered to be profitable. Between the two class III railroads operating the branch, the B&SW still has potential waiting to be exploited.

New York & Lake Erie 6764 and 308 bask in the morning sun before beginning a private photo charter excursion event.

NYLE FPAs 6758 and 6764 sit inside the engine shed in Gowanda.

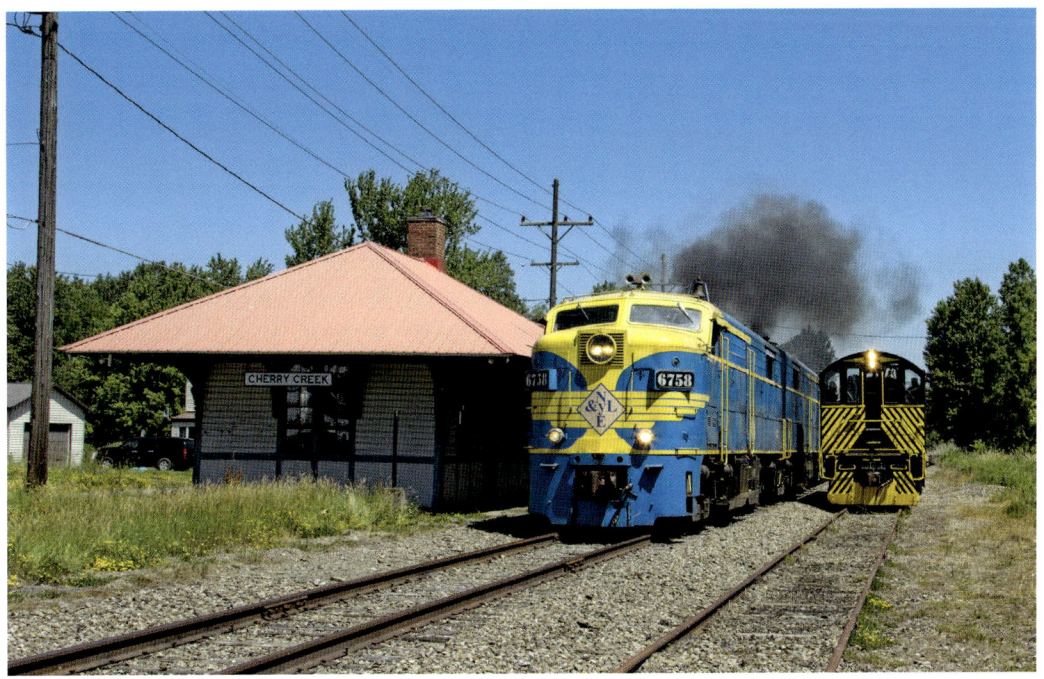

Slowly navigating the former Erie main line with an empty train in tow, no. 308 crosses a quiet country road with an old crossbuck that still guards the seemingly forgotten right of way.

While most of the railroad's passenger excursions turn around at South Dayton, some will continue onward to Cherry Creek, which currently serves as end of the line for the New York & Lake Erie. The right of way south of Cherry Creek currently remains out of service.

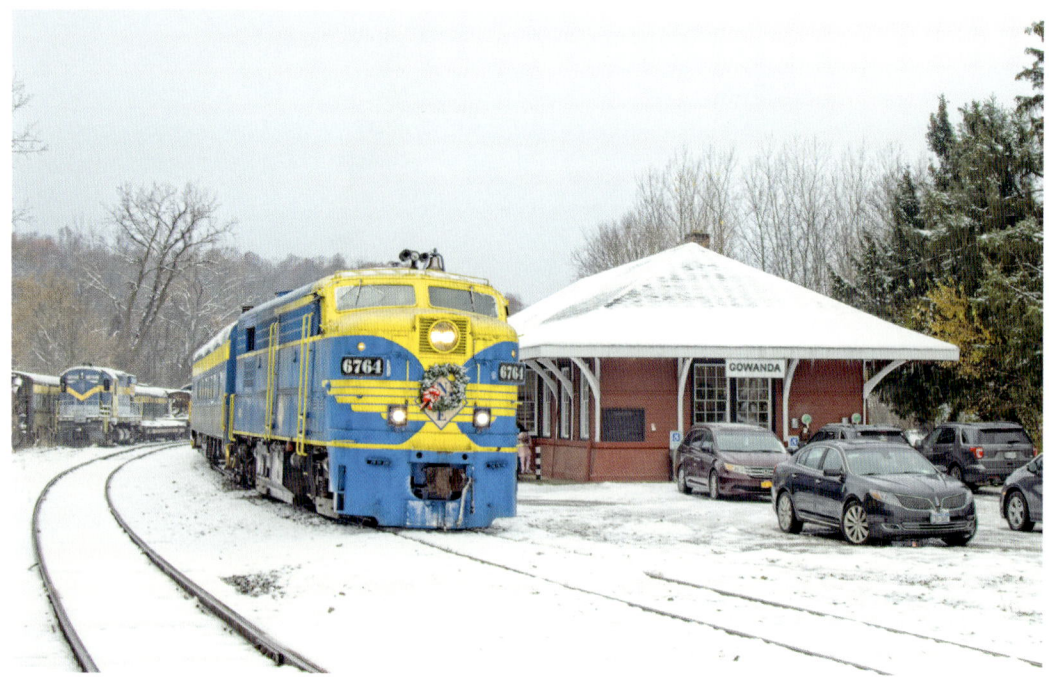

The New York & Lake Erie Railroad's home base of operations is in Gowanda, New York. Passenger excursion trains run between Gowanda, South Dayton, and Cherry Creek.

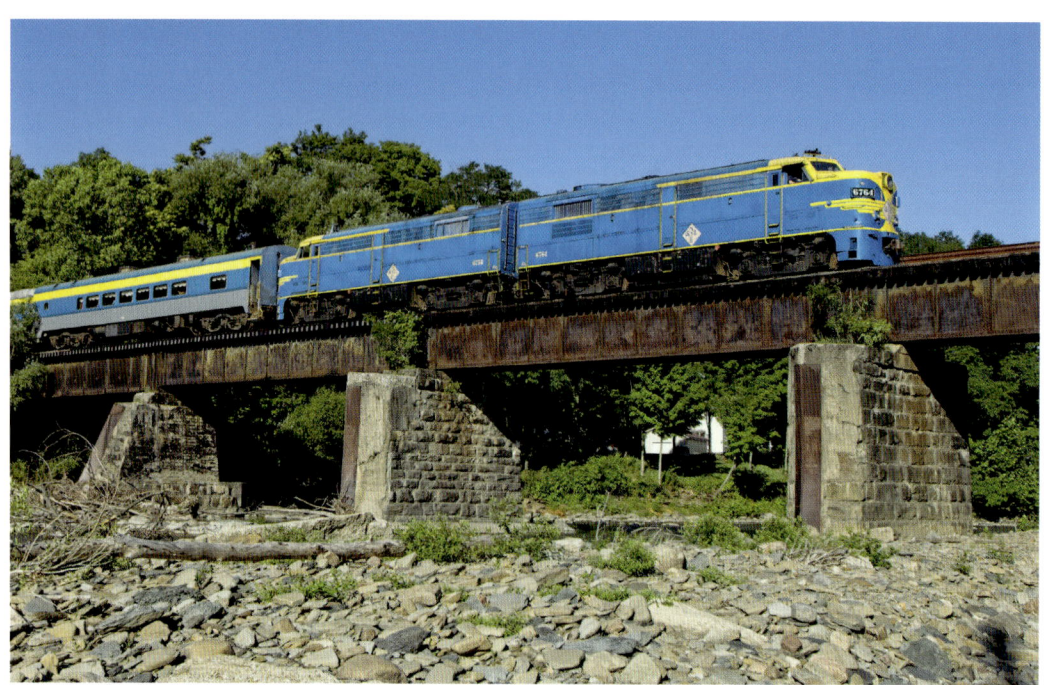

Nos. 6764 and 6758 slowly cross the Cattaraugus Creek for photographers during the morning session of a photo charter. Buffalo Southern right of way begins on the north side of this bridge while the New York & Lake Erie right of way begins on the south side.

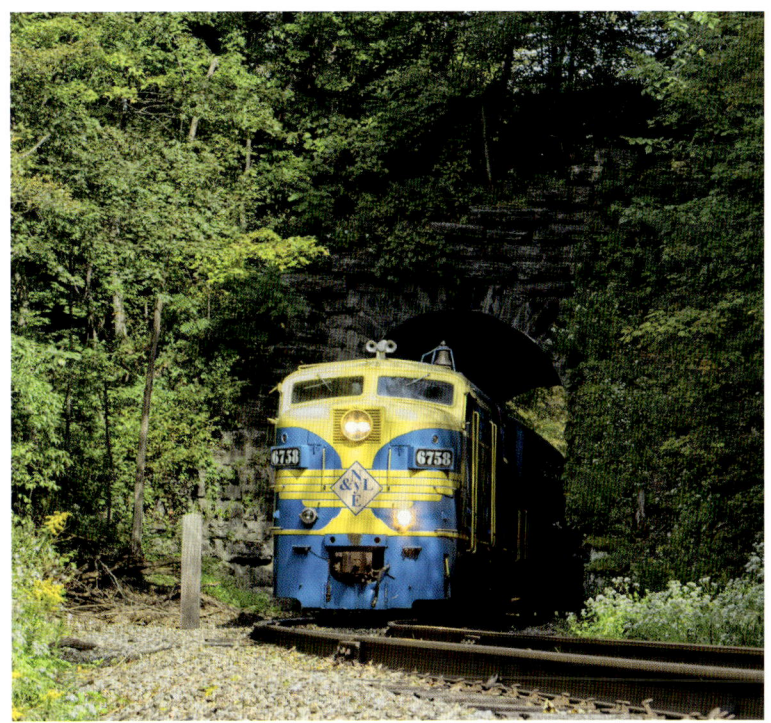

One popular photo location on the New York & Lake Erie's portion of the Buffalo & Southwestern branch is the tunnel at Dayton. The original Erie Railroad right of way, which is now abandoned, ran directly above the B&SW branch here at the tunnel.

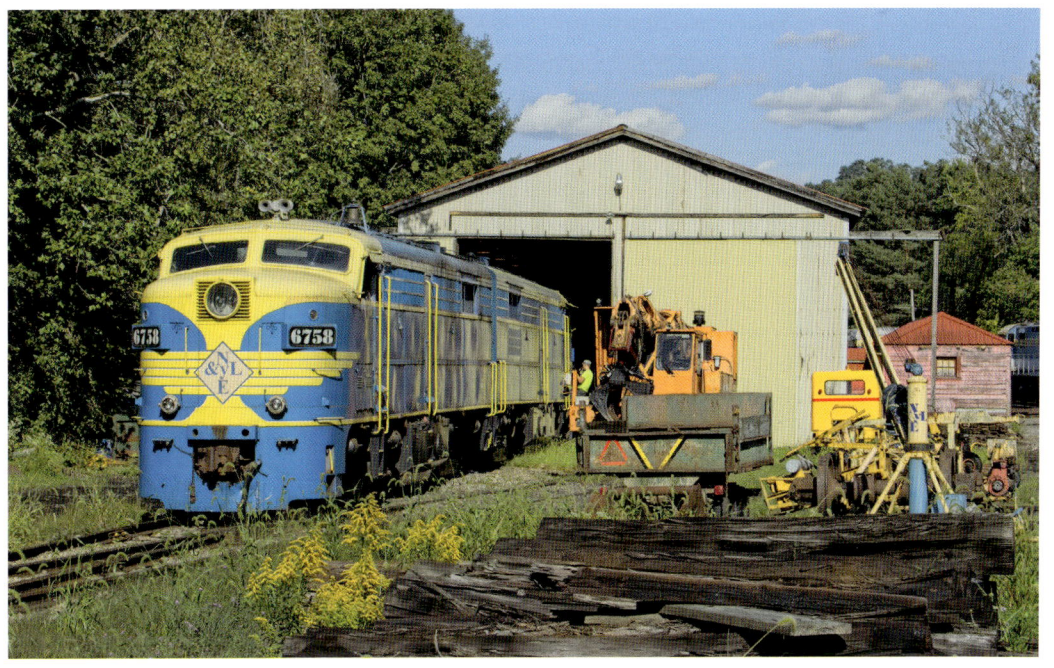

Nos. 6758 and 6764 conclude a day of excursions in Gowanda.

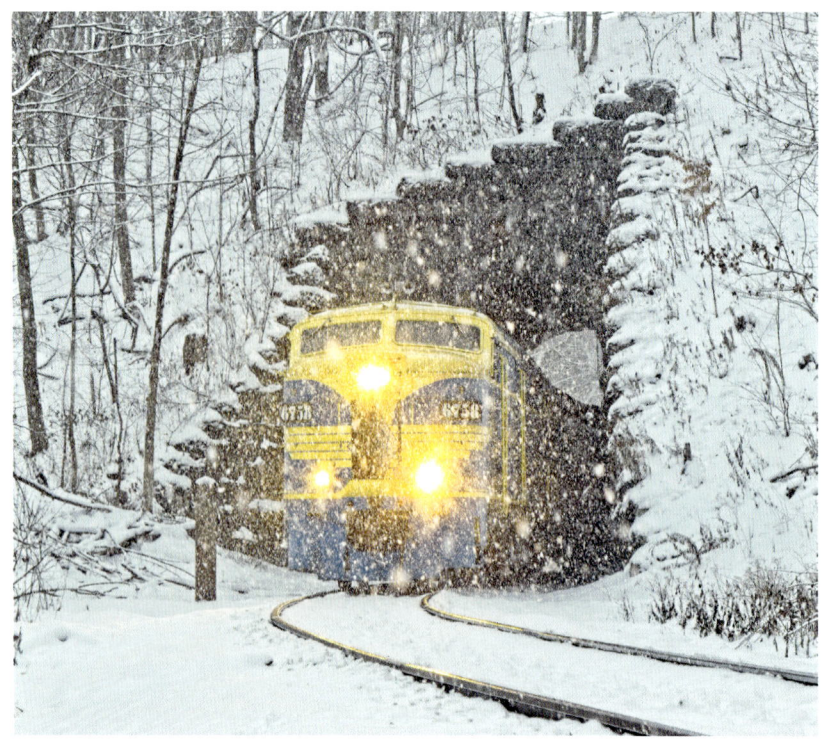

The Santa Express exits the tunnel while heavy snowfall covers the Dayton area in early December 2021.

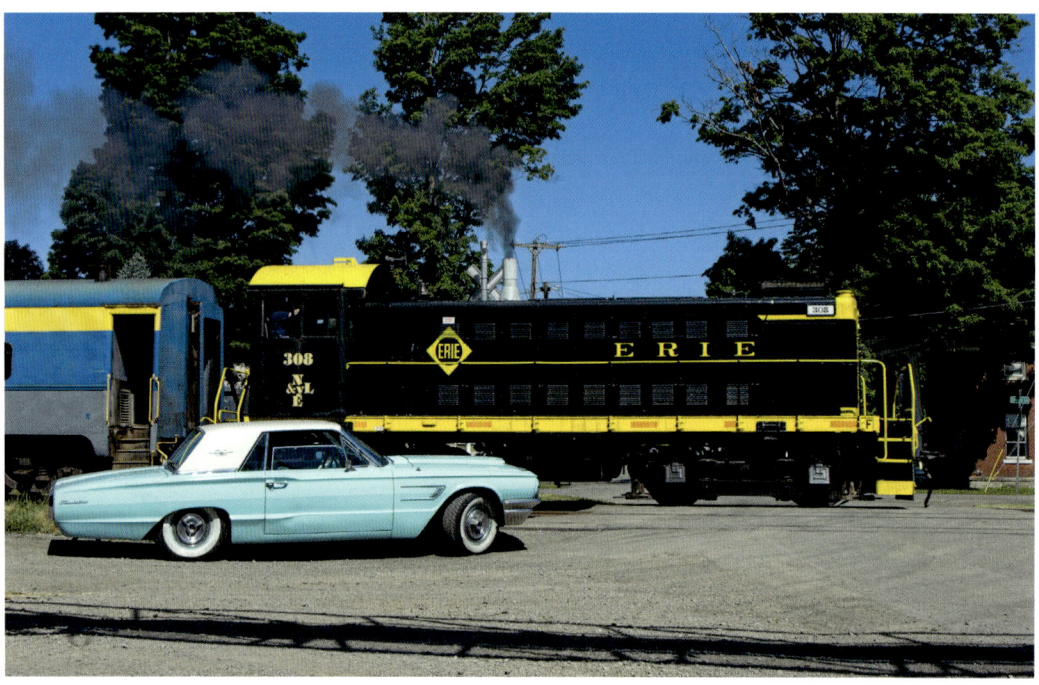

No. 308 highballs out of South Dayton with the excursion consist in tow while a 1965 Ford Thunderbird watches the train depart.

NYLE ALCO FPA no. 6758 and S-1 no. 308 lead an evening murder mystery special through Dayton at golden hour.

No. 308 idles at Gowanda depot after returning from a late summer photo charter. Like the tracks it operates on, no. 308 is also of Erie Railroad heritage.

NYLE 6764 and the Santa Express cross Hill Street in Gowanda with 6758 bringing up the rear.

As part of a private photo charter event, 6758 and 308 pose for photographers at "DM" Junction in Dayton, NY. The 6758 is posed on the B&SW branch while the 308 is posed on the switchback leading to the original Erie mainline that once ran from Dunkirk to Piermont, New York.

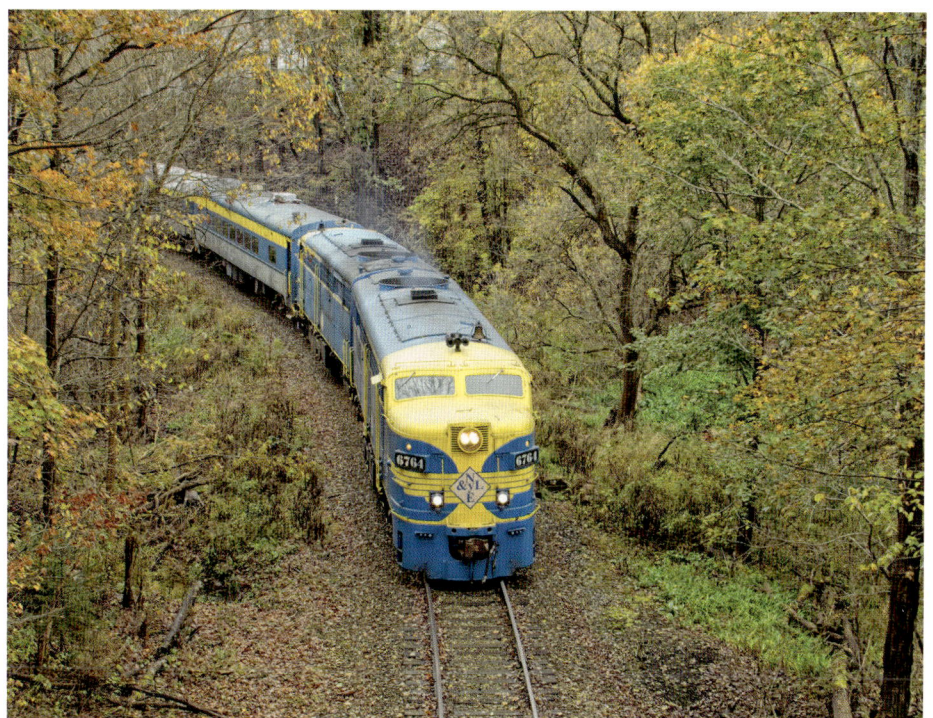

NYLE 6764 and 6758 begin to enter the tunnel with the last of the fall color on display in Dayton.

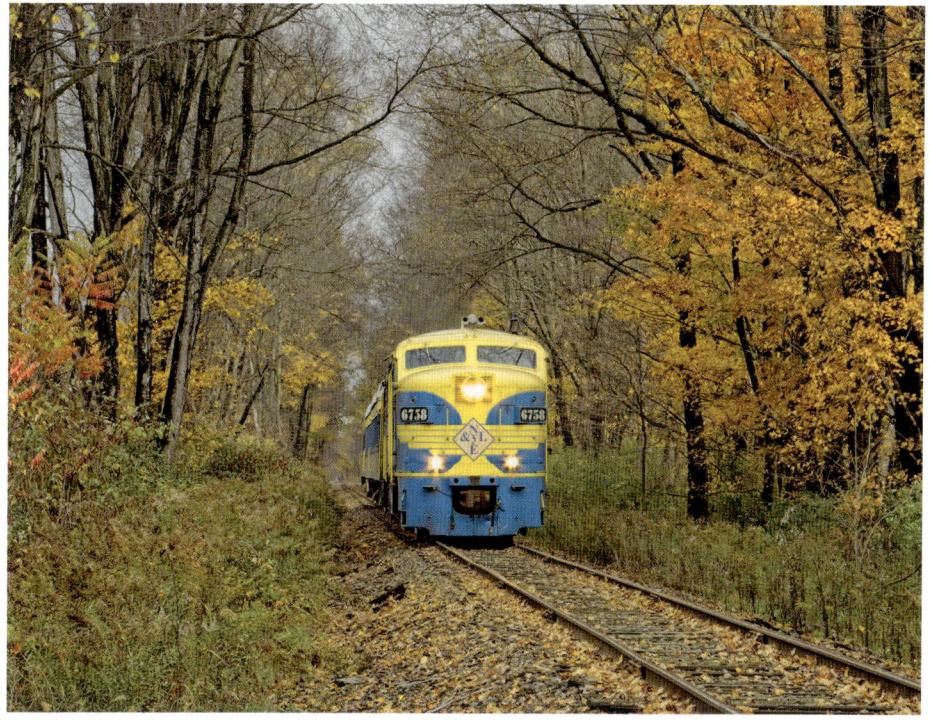

The NYLE excursion train picks up speed in Markhams on the last leg of the journey to South Dayton.

No. 308 poses for photographers in Gowanda while doing what Alco diesel locomotives are widely known for.

Running around their train in South Dayton, no. 308 will lead for the return journey back to Gowanda.

The past meets the present at Cherry Creek depot as a horse and buggy pose in front of the former Erie Railroad depot and the diesel-powered iron horse that is seen idling behind them.

On a warm afternoon in August 2021, 6758 and 6764 arrive in South Dayton with a photo charter.

No. 308 catches the last rays of the evening sun as it waits to depart South Dayton.

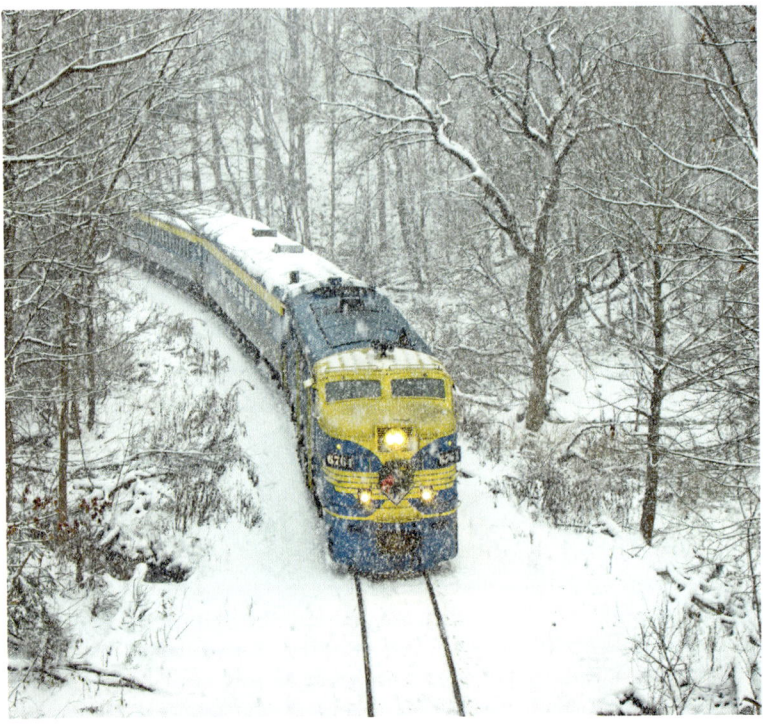

The Santa Express rounds the bend in Dayton before entering the tunnel amidst heavy snowfall.

2

THE ARCADE & ATTICA:
The Railroad That Time Forgot

The Arcade & Attica Railroad operates revenue freight and passenger excursion services on 14 miles of its original right of way between Arcade and North Java, New York. The A&A is widely known for being the only railroad in the state of New York to have a steam locomotive in operation, often dubbed as "Western New York's Steam Railroad." In the state of New York, there are currently two steam locomotives that are maintained and regularly operated: Viscose Company 0-4-0T no. 6 (owned and operated by Scott Symans of Dunkirk, NY) and Arcade & Attica's 2-8-0 consolidation no. 18.

Even though the Arcade & Attica was organized and founded in 1917, the railroad's rocky history is filled with disappointment and financial struggle during its earliest years between 1836 and 1917. The story of the Arcade & Attica is one of hopes, dreams, failure, ambition, a long list of bankruptcies, and rebirth. Unlike most short line railroads of the modern twenty-first century that are typically owned by large holding companies and conglomerates, the A&A has remained a privately held company among the citizens that inhabit the area to this day. If one was to visit the Arcade and North Java area, the scenic rural country side and small-town America atmosphere that you experience makes you start to think that time itself forgot about this small local railroad nestled among the farms and hills of western New York.

The story of the Arcade & Attica began in 1836 when the Attica & Sheldon Railroad was chartered with the purpose of providing rail service to the area's farming and agricultural industry. However, the company never made it outside of paper. In 1852, another effort to build a railroad in the area was conceived. This railroad became known as the Attica & Alleghany Railroad, which was organized with the purpose of

connecting Buffalo, New York, with Pittsburgh, Pennsylvania, via a standard-gauge route through Arcade and Attica, New York. Unlike the Attica & Sheldon, the Attica & Alleghany somewhat made it off of paper. The newly organized railroad managed to acquire right of way, grade the newly acquired property between Arcade and Attica, build and install bridge abutments, and purchase rail. These signs of progress would abruptly end once the railroad went bankrupt and was sold under foreclosure in February 1856. The next attempt to build a railroad in the area was made with the formation of the Attica & Arcade Railroad in 1870 to complete the efforts made by the Attica & Alleghany. This third attempt would also quickly fail as a result of the financial panic of 1873.

The building of the railroad did not start making any actual headway until the early 1880s when former director of the old A&A, R. N. Farnham, formed the Tonawanda Valley Railroad. Through this venture, he was able to open 19 miles of track from Attica, which allowed him to make a connection with the Erie's Buffalo branch in September 1880. Continued work and efforts allowed the railroad to reach Arcade at 26 miles of track in May 1881. For the promoters of the railroad, this was only the beginning. Between 1881 and 1882, this new railroad that finally connected Arcade and Attica would go on to build up to 59 miles of track with great aspirations to connect to neighboring railroads and tap into the region's oil industry that was booming at the time. This railroad became known as the Tonawanda Valley & Cuba Railroad when all properties were officially merged into the TV&C.

This success would once again prove to be short-lived when the oil industry collapsed in 1883 only a year later. As a result of this devastating blow, the TV&C went into receivership in 1884 and went through a number of failures and name changes. The final nail in the coffin was driven in January 1891 when the railroad was sold to become the new Attica & Freedom Railroad. Unfortunately, the A&F would also be added into the long line of failures when it too fell into bankruptcy within a few years of operation.

In October 1894, the A&F property was acquired by Spencer Bullis, who reorganized it as the Buffalo, Arcade & Attica Railroad. Bullis, who worked in the lumber industry, began changing the railroad's track gauge from narrow gauge to standard gauge with the segment between Arcade and Curriers being completed in January 1895. The remaining sections of the line were finished several months later in December of that year, and services began operating only a month later.

Bullis would ultimately be the one to make the decision to build the southern interchange point in Arcade in order to connect with the Pennsylvania Railroad. The BA&A opened this 2-mile-long connector from Arcade in 1897 and would quickly become known by locals, railroad personnel, and rail enthusiasts as Arcade Junction.

Since being opened in 1897, Arcade Junction holds the distinction of being the railroad's primary outlet with the outside world. Today, Arcade Junction still serves as the A&A's interchange point with the new owners of the Pennsylvania Railroad right of way: the Buffalo & Pittsburgh Railroad.

A few years later in 1904, the BA&A was sold to Frank Goodyear as a subsidiary company of his own railroad: the Buffalo & Susquehanna Railway. The Buffalo & Susquehanna would eventually find itself joining the long line of failures consisting of the BA&A's predecessors in 1910 when the railroad failed and became part of the Baltimore & Ohio. Following the failure of the B&S, the BA&A was spun off and continued to operate independently until the BA&A found itself declaring bankruptcy once again in March 1917.

When the Buffalo & Susquehanna Railroad spiraled into bankruptcy in March 1917, the railroad was thinking of closing down the BA&A section which raised many concerns for the businessmen of the area. The Merrell-Soule Company of Arcade, which was the predecessor to the Borden Company, operated a large milk processing plant and they, as well as many other local industries in the area, needed rail service and were not willing to lose it. With the line now facing closure, money began to be raised by interested parties to purchase the railroad with stock being sold to local farmers, merchants, and anyone else who was interested in saving the railroad. Some 365 people raised a grand total of $79,000 to purchase the line, and on May 23, 1917, only a few months after going bankrupt, the modern Arcade & Attica Railroad was born.

Following its final rebirth in 1917, the Arcade & Attica began to see a considerable amount of success that its predecessors could only dream of. Leading into the 1920s and the Great Depression in the 1930s, the railroad never encountered any sort of financial trouble. In fact, the Arcade & Attica prided itself on the fact that the railroad never laid off a single employee during the unforgiving full length of the Great Depression, so much so that the 1930s were considered to be the boom times for the tiny railroad.

The age of steam would quickly come to end on the A&A in the 1940s when the railroad realized it needed to reduce expenses. In 1941, the A&A purchased its first diesel locomotive: General Electric 44-ton switcher no. 110. With the purchase and arrival of the 110, the A&A became one of the first railroads in the United States to begin operations with diesel locomotives. The small center cab diesel switcher became an immediate success for the A&A and drastically cut expenses to the point where it was declared that the 110's arrival had saved the railroad from bankruptcy. The age of steam on the A&A would come to an official end in 1947 when the railroad purchased a second 44-ton switcher, no. 111, from General Electric. With 110 and 111 now in

charge of the A&A's daily operations, the railroad had become fully dieselized and steam had completely disappeared from the A&A railroad scene.

For the Arcade & Attica, the boom times came to an end in the 1950s. The railroad made the final decision to end its remaining passenger services in 1951 and freight traffic began to severely decline. With passenger services eliminated and freight traffic disappearing rapidly, the A&A was once again faced with financial issues. With very little options remaining for the tiny short line railroad, management decided to roll the dice on becoming a tourist railroad.

The sound of steam whistles once again filled the Arcade countryside with the crown jewel of the modern A&A, 2-8-0 consolidation no. 18, arriving on the property in 1962 from the Boyne City Railroad of Boyne City, Michigan. Another steam locomotive from Michigan, this time hailing from Michigan's Upper Peninsula on the Escanaba & Lake Superior Railroad, arrived on the property to assist no. 18 with excursion services the following year in 1963. This second steam locomotive was 4-6-0 ten-wheeler no. 14. Along with the purchase no. 18, the A&A also purchased two Delaware, Lackawanna, and Western coaches for the steamers to operate excursions with.

The inaugural run of the A&A's tourist trains took place on July 27, 1962, with regular summertime excursions beginning in August. The trains ran on an all-day schedule with just two passenger cars and the excursion trains turned out to be a big success. After carrying 17,000 passengers in the railroad's first season, the A&A was quick to purchase more DL&W passenger cars when the railroad bought no. 14 in 1963. Having found a new way to keep the railroad in business, the Arcade & Attica Railroad quickly became known as the "Grand Scenic Route."

Before the re-introduction of steam power in the early 1960s, the 1950s was also the time where the railroad's system was cut nearly in half when the Tonawanda Creek flooded in 1957. On portions of track south of Attica, several hundred feet of the Arcade & Attica's right of way was completely washed away. When the railroad assessed the cost of repairs to the north end of their line, it was determined that the $72,000 price tag was too much to pay for the tiny short line. The decision to suspend all operations between North Java and Attica was quickly made by the board of directors on January 25, 1957. This decision was made based on the logic that nearly all of their remaining freight business was situated between Arcade and North Java. After getting permission from the ICC, the tracks from North Java to Attica were abandoned.

Today, the Arcade & Attica's right of way begins at the Buffalo & Pittsburgh interchange at Arcade Junction and ends at the industrial sidings of two of their remaining freight customers: Buffalo Molasses and Reisdorf Brothers Feed Mill. The railroad's remaining right of way consists of 14 miles of the original A&A mainline with a handful of small

sidings for the storage of railroad equipment between Arcade and North Java. The railroad added General Electric 65-ton diesel switcher no. 112 to the roster in 1988 with an 80-ton switcher, no. 113, being the latest addition to the railroad in 2014. With 112 and 113 on the property, the service lives of their smaller 44-ton cousins were over. No. 110 was retired from service and currently sits on static display in downtown Arcade next to the railroads active right of way and the Cattaraugus Creek. No. 111 resides at the A&A's small locomotive facility in storage as a backup engine waiting for its next call to duty should the need ever arise. No. 14 currently sits in storage at the A&A's shops in Arcade awaiting an expensive overhaul and restoration. No. 18 continues to operate as the railroad's main attraction for passenger excursions to Curriers.

As of 2022, no. 18 is currently out of service undergoing a full rebuild. Scenic highlights along the A&A's route include: Downtown Arcade, the Cattaraugus Creek, the station in Curriers, Java Center Depot, the Beaver Meadow trestle bridge, Ghost Pond, and the Reisdorf Brothers Feed Mill. Navigating through the rural farm country and hills of western New York with classic steam and diesel power, the Arcade & Attica Railroad is a time capsule that has truly stood against the test of time.

No. 110, the diesel locomotive that is considered to have saved the railroad, sits on static display in Arcade, New York, next to the Arcade & Attica's main right of way.

After a brief stop at Java Center, 112 and 113 prepare to continue the journey south to Arcade. The short line of tankers and covered hoppers that were picked up from the Reisdorf Bros. Feed Mill are now bound for interchange with the Buffalo & Pittsburgh Railroad at Arcade Junction.

No. 113 passes by the old A&A snowplow that currently sits on static display in front of the Arcade Fire Department during a photo runby for a private charter group.

Located at Beaver Meadow Road just north of Java Center, the trestle bridge that spans over this small country road is one of the most notable photo locations on the A&A.

Arriving back in Arcade, 112 and 113 begin to cross the Cattaraugus Creek during a cold afternoon in early December.

Rounding the bend at the north end of Arcade, no. 112 leads the A&A's southbound freight on the home stretch to Arcade Junction.

The Arcade & Attica's main passenger depot is located right in the middle of downtown Arcade on Main Street. No. 113 is seen here arranging the passenger consist for the weekend excursions to Curriers.

The A&A's southbound freight train heads back into Arcade with the fall color now showing on the leaves.

45

Agway was a former customer that the Arcade & Attica served until June 2000.

Reisdorf Brothers Inc. is one of the last remaining customers the railroad serves. Deliveries to Reisdorf typically happen once per week.

No. 113 leads 112 and a line of loaded hoppers northbound out of Arcade.

No. 113 leads the Railway & Locomotive Historical Society charter train northbound to North Java at Beaver Meadow Road.

47

No. 112 idles at Curriers depot during a brief layover.

After servicing Reisdorf Brothers Feed Mill, the A&A crew prepare to depart North Java for Arcade.

Nos. 113 and 112 slowly bring their northbound train into North Java.

After picking up their train at Arcade Junction, 113 and 112 begin the northbound journey to North Java while passing an abandoned factory.

No. 113 waits to depart Curriers with a weekend excursion.

After flagging the NY-78 crossing in Java Center, 113 and 112 continue the journey northbound with only a few miles to go before arriving in North Java.

No. 112 leads a private charter excursion across the trestle at Beaver Meadow Road while a truck passes underneath.

With relatively calm winds in the area, the reflections of the southbound A&A freight train can be seen on the water of Ghost Pond.

After arriving in North Java, the A&A crew begin switching and servicing Reisdorf Brothers Feed Mill.

The A&A crew can be seen here switching the Reisdorf Brothers Feed Mill.

52

No. 112 leads a southbound freight past Ghost Pond.

The depot at Java Center is one of three old railroad depots that are still located along the A&A's tracks. Java Center is also a location where the A&A crew can refuel their diesel locomotives.

During the early morning hours, No. 112 idles at the railroad's station in Arcade while waiting for passengers to board for a private charter excursion to North Java.

No. 113 leads a northbound freight train past the old Agway mill as the sun rises on Arcade.

Arcade Junction is the A&A's interchange point with the Buffalo & Pittsburgh Railroad.

A northbound A&A freight train passes the abandoned factory as the winter weather takes hold of the western New York region.

55

The weekly southbound A&A freight arrives back in Arcade as the railroad's first diesel switcher watches its center cab cousins continue to serve the railroad even after their kind became obsolete decades ago.

The Railway & Locomotive Historical Society charter train heads southbound along the edge of Ghost Pond. The train's reflection can be seen clearly with the water being in a calm state.

No. 113 leads its northbound freight into Curriers on a cold December morning.

No. 112 leads a small excursion train southbound from North Java.

3

THE FALLS ROAD RAILROAD:
The Erie Canal's Successor

The Falls Road Railroad, a subsidiary company of Genesee Valley Transportation, is a small 41-mile short line railroad that operates between Lockport and Brockport, New York. The subsidiary of Genesee Valley Transportation got its name due to the tracks dating back to the days of the New York Central, when it was known as the New York Central's Falls Road Branch. Under Conrail, this branch was known as the Falls Road Secondary.

The Falls Road began operations in October 1996 after the old branch line was acquired from Conrail. Like many of the short line railroads in New York, the Falls Road employs Alco diesel locomotives to power the revenue freight trains and passenger excursions that the railroad operates on a regular basis. The route of the Falls Road runs somewhat parallel to the famed Erie Canal between Lockport and Brockport and passes through the cities of Gasport, Middlesport, Medina, Albion, Fancher, and Holley. As the tracks end at a small industrial junction in Brockport, all freight traffic is interchanged with CSX in Lockport. Freight traffic on the Falls Road consists of grain, fertilizer, chemicals, lumber, and food products.

Occasionally, the railroad will operate passenger excursions with the Medina Railroad Museum as well. Scenic highlights along the route to Brockport include the inverted steel trestle bridge spanning over the Erie Canal in Lockport, the former New York Central passenger depot in Albion, the railroad museum and passenger depot in Medina, the overpass and cold storage siding in Holley, the Bonduelle factory in Brockport, and various rural farm country scenes throughout the entirety of the Falls Road's route. Rich with history and still alive with industrial activity, the Falls Road is a railroad that is always kept busy.

Before the railroads, there was the Erie Canal. Tracing its very beginnings to 1807, the Erie Canal is a 363-mile-long waterway that connects the Great Lakes with the Atlantic Ocean via the Hudson River in upstate New York. Traversing from Albany to Buffalo on Lake Erie, the Erie Canal was considered an engineering marvel when it first opened in 1825 as a direct water route from New York City to America's Midwest. Much like the railroads that succeeded it as a mode of transportation, it triggered a large-scale commercial and agricultural development boom. Thanks to the canal's connection to the Great Lakes, immigration to the soon to be populated frontiers of western New York, Ohio, Michigan, Indiana, and points farther west also increased. Early explorers in America had long searched for a water route from the East Coast to the Midwest and the next frontier known as the Northwest Territory had natural resources that many American settlers were looking to exploit. During the eighteenth and early nineteenth centuries, it took weeks to reach these resources by the current modes of land travel. Transporting goods by bulk was severely limited by what teams of oxen could pull by wagon and the lack of an efficient transportation network confined American populations and trade to the coastal areas.

Beginning in 1807, a flour merchant from Western New York known as Jesse Hawley advocated for a canal system that would span nearly four hundred miles from Buffalo to Albany, New York after going broke trying to get his product to market in the Atlantic coastal cities. While in debtor's prison, Hawley published a series of essays that caught the attention of many New York politicians, including New York City Mayor Dewitt Clinton. Like Hawley, Clinton believed that the canal was imperative to the economic advancement of his city. Clinton would see his plan come to fruition in 1817 after he became the governor of New York. Workers began construction in July 1817 and first broke ground near Utica, New York. Upon its completion in 1825, the original Erie Canal was 4 feet deep and 40 feet wide and was labeled as a major engineering feat of its time. It traversed almost 400 miles and contained eighty-three locks.

Officially opening on October 26, 1825, a fleet of boats led by Governor Dewitt Clinton on board the *Seneca Chief* sailed from Buffalo to New York City in a record time of just ten days. Thanks to the completion of the Erie Canal, New York City's population quadrupled between 1820 and 1850 and the city surpassed Philadelphia as the country's most important banking center. The Erie Canal also provided an economic boost to the entirety of the United States by transporting goods at one-tenth of the previous cost in less than half of the previous time.

By 1853, the canal carried 62 percent of all U.S. trade. However, at the same time, the railroads were quickly having a negative effect on travel via the Erie Canal. By the 1850s, people began to prefer the comfort and speed of the railroads over packet boat

travel on the canal. The railroads were more expensive but not by a large amount. The rail fare from Buffalo to Albany in 1850 was $10 while the corresponding fare by packet boat was $6.50, including means for the five-day journey. With the railroads taking over as the main mode of transportation, the packet boat had become a novelty rather than a necessity, so much so that the packet boats were completely driven out of business by 1860.

The Falls Road traces its origins to the Lockport & Niagara Railroad which was chartered in April 1834. Completed in 1838, the Lockport & Niagara was built to approximately 20 miles in total length. The Rochester & Lockport Railroad was also chartered during this four-year period in May 1837, but not much work was done except for a small amount of grading and bridge construction. In 1850, a state charter was granted to the reorganized Rochester, Lockport & Niagara Falls Railroad and began operating on approximately 76 miles of track between Niagara Falls and Rochester via Lockport. This railroad line officially opened to rail traffic in 1852.

As the railroads increased their presence in the area, the Erie Canal became surpassed by the Falls Road Branch as the primary way to travel between Albany and Buffalo. By 1841, barely fifteen years had passed since the completion of the Erie Canal in 1825. Thanks to the Falls Road, it became possible to travel between Albany and Buffalo in twenty-five hours. Travel time between Albany and Buffalo eventually got cut down to approximately twelve hours by the start of the following decade.

Since the 1800s, the route of the Falls Road has remained rural and agricultural in its nature. Before passenger services ended in 1957, the Falls Road once saw as many as six passenger trains a day operating westbound and eastbound as a commuter service. Commuter services on the Falls Road paired Lockport with Niagara Falls and Rochester with Albion. To accommodate for all of the rail traffic of the time and eliminate delays, the Falls Road was double tracked by the New York Central in 1929. The branch was doubled tracked for approximately 75 miles in order for Michigan Central (a NYC subsidiary) trains to have a more direct route via the suspension bridge on the Falls Road instead of going through Buffalo. Like the rest of the New York Central's system, the Falls Road became a part of Penn Central upon the merger with the Pennsylvania Railroad and New Haven Railroad in the late 1960s before becoming Conrail's Falls Road Secondary in 1976. The line would continue to operate under Conrail into the early 1990s with the right of way from Brockport to Rochester being abandoned and pulled up in 1994. Conrail would then sell the Falls Road to its new namesake short line railroad operator two years later, and a new ALCO powered subsidiary of Genesee Valley Transportation was born.

Built as New York Central 8035 in 1962, no. 2035 still operates on this former New York Central branch line as Genesee Valley Transportation 2035.

Heading eastbound to Brockport, no. 2035 leads a short freight consist through Gasport.

No. 2035 heads eastbound light engine outside of Middleport.

Falls Road Alco RS-11 no. 1802 arrives in Knowlesville to drop off its cut of covered hoppers and tank cars before continuing east to Brockport.

No. 2035 services a recently acquired customer in Medina.

No. 2035 passes by Growmark's facility in Knowlesville. The covered hoppers in the siding will be picked up later on the westbound return trip to Lockport.

The old depot in Albion, despite being boarded up and looking abandoned, is remarkably intact and is one of the mainstay photo locations on the Falls Road for photographers.

Running through Holley eastbound, 2035 with a single boxcar in tow passes milepost 23 and the Holley Cold Storage siding.

No. 2035 passes through Albion westbound with a cut of boxcars that were picked up in Brockport.

The clock in Fancher serves as a memorial to local citizens who sacrificed their lives in World War II.

65

As 2035 picks up more freight cars bound for Lockport, a young man watches as the Falls Road crew works the sidings in Knowlesville.

The iconic bridge over the Erie Canal in Lockport was built in 1902 by the King Bridge Company of Cleveland, Ohio. The main span that crosses the canal is a Baltimore deck truss and is often referred to as the "Upside-Down Bridge" because as a deck truss, it looks like a through truss that is positioned upside-down.

After servicing multiple customers in Medina, 2035 leads a lengthy westbound freight train back to Lockport to be interchanged with CSX.

The railroad's steel bridge in Lockport was rumored to have been built the way it was to limit the size of boats that could use the Erie Canal and attempt to put the canal out of business. The validity of this rumor is uncertain.

No. 1802 approaches Albion westbound with a pair of refrigerator cars that were picked up from Bonduelle's facility in Brockport.

No. 1802 leads a routine westbound freight back to Lockport.

No. 1802 crosses over the Erie Canal in Lockport.

No. 1802 pulls out two refrigerator cars out of the spur at Bonduelle.

4

THE BUFFALO & PITTSBURGH:
The Modern BR&P

The Buffalo and Pittsburgh is a class II regional railroad operating between its namesake cities under the ownership of Genesee & Wyoming Inc. Winding its way through the hills of western New York and the mountains of northeastern Pennsylvania, the Buffalo and Pittsburgh offers a glimpse of classic railroading operating amongst the gorgeous scenery and the vintage Baltimore & Ohio Railroad signals. On top of the scenery and vintage signals, older EMD diesel locomotives frequently mingle with the latest castoffs of the larger class one railroads of the modern present.

In the state of New York, the B&P operates between Buffalo, Arcade, Machias, West Valley, and Salamanca before entering the state of Pennsylvania in Bradford. Beyond the city of Bradford, the Buffalo & Pittsburgh continues to navigate the mountains of northeastern Pennsylvania, reaching major cities such as Driftwood, Homer City, Freeport, Erie, New Castle, and Pittsburgh. On the north end of their system in New York State, one can find various coal drags, billet trains, and general manifest freight being moved in and out of Buffalo. The local BF-2 job can be seen making a once a week run to Arcade to service Kent Nutrition or interchange freight traffic with the Arcade & Attica Railroad. Manifest freight and billet trains between Buffalo and Salamanca can be seen operating on a daily basis as well. If a rail enthusiast wanted to visit a railroad that hustles heavy freight along a former Baltimore & Ohio mainline with older EMDs, then the Buffalo & Pittsburgh is a reliable and remarkably accessible option.

Before the Buffalo & Pittsburgh, a significant portion of their network was known as the Buffalo, Rochester, and Pittsburgh Railway. Operating under this name since 1887, the BR&P's roots dated back to the Rochester & State Line Railroad that was

organized to tap into the coal fields of northwestern Pennsylvania in April 1869. The R&SL was completed from Rochester to Salamanca, NY in early 1878 and made connections with the Atlantic & Great Western Railroad in Salamanca. This allowed the railroad to reach the increasing number of railroad lines that extended into the coal and oil fields of the region. Like many of the small railroads of the time, the financial strains of acquiring property and equipment, as well as with actual construction work of the right of way, lead to bankruptcy. This forced the company to reorganize as the Rochester & Pittsburgh Railroad in January 1881.

Now reorganized as the R&P, this new railroad company set to increase the strength of its own competitive position by building its route deep into the Pennsylvania coal country. The railroad's mainline arrived in Punxsutawney in 1883 and a branch line to Buffalo was also nearing completion. Through passenger trains began operating in June of that year after operating rights into Pittsburgh with the Alleghany Valley Railroad were secured. Also, coal trains soon began to operate between the Rochester & Pittsburgh Coal & Iron Company mines and the Great Lakes transfer facilities in Buffalo and Rochester. Operating as a north–south railroad, the R&P crossed numerous rail lines that extended across New York State, which provided a considerable amount of interchange traffic for local customers along its route. Despite business growing rapidly for the railroad, the R&P's financial resources had quickly run dry during its expansion, which made the railroad enter foreclosure proceedings as a result in May 1885.

Adrian Iselin, one of the R&P's major stockholders from New York City, refused to lose his investment and purchased the bankrupt R&P in October of that same year through two companies: the Pittsburgh & State Line Railroad in Pennsylvania, and the Buffalo, Rochester & Pittsburgh Railroad in New York. These two companies would operate under the BR&P name and were formally consolidated as the Buffalo, Rochester & Pittsburgh Railway in March 1887.

Expansion of the BR&P continued for the next twenty years with the extension of its own route being built towards Pittsburgh, new coal and ore docks being built in its northern terminals, and beginning a car ferry service across Lake Ontario. The BR&P was soon given its "safety and service" reputation among travelers as new and improved passenger stations were constructed along with newer equipment being acquired. On top of all of that, more branch lines were being built to the growing coal fields of northwestern Pennsylvania in order to maintain a consistent flow of coal supplies.

However, following World War I, the BR&P began to face new challenges. Like many railroads of the Northeast, the BR&P, in terms of infrastructure, had become worn down due to heavy wartime traffic during the years of government control and was struggling to recover from the war. To make things even more complicated, the coal

market was becoming increasingly competitive with new mines opening in the southern states. As a result, the BR&P's most important traffic base was greatly reduced in terms of profitability. Going into the 1920s, the BR&P also found itself in the midst of corporate turmoil with investors from larger railroad companies fighting for control of the smaller railroads. In 1928, the majority of the BR&P's stock was acquired by the Van Sweringen brothers, the owners of the Chesapeake & Ohio and the Nickel Plate Road.

One year later in 1929, the stock market crash had thrown the United States into the Great Depression. As a result, investors scrambled to divest their interest in speculative securities while the Interstate Commerce Commission was drawing up plans for consolidating the railroads into multiple major systems. This led to more changes in the ownership of various rail lines with companies making joint agreements with connecting railroads or attempting to outright purchase them. During this period of uncertainty, the Baltimore & Ohio Railroad would become interested in acquiring the BR&P. The B&O acquired majority stock ownership of the BR&P in January 1932 and officially took over operations.

Upon acquisition, the BR&P name immediately disappeared with the B&O's logo taking its place on equipment, timetables, and even dining car china. For the B&O, the original plan was for the BR&P to become part of an alternate mainline route from Pittsburgh to New York via the Reading at Williamsport, PA and the Central Railroad of New Jersey, which was already part of the B&O's "Royal Blue" route. However, this plan never came to fruition and operations on the BR&P continued as normal prior to the takeover by the B&O. As part of the ICC's approval for the B&O's purchase of the BR&P from the Van Sweringen brothers, who owned 85 percent of outstanding shares, the B&O was required to acquire all additional BR&P stock that was privately held. During this transaction, the B&O offered to purchase BR&P stock at $100 per share, which resulted in the railroad obtaining 99.96 percent of both the common and preferred stock. While at this point it was clear that the B&O owned the BR&P, a few shares remained unaccounted for due to a small handful of "silent partners" still holding onto their shares.

World War II brought a temporary surge of traffic to the former BR&P as industries throughout its network worked around the clock to supply the war effort. Throughout the railroad, coal and ore drags were being pulled by large mallets to the steel mills and coke ovens while passenger trains were filled to capacity with wartime travelers. This increase in business would dissipate starting in the 1950s when Americans took to the highways in their automobiles and took to the skies with the airlines. Passenger services on the former BR&P ended in 1955 and local freight traffic on the north end began to decrease. Despite this, the coal business kept the BR&P trains running as well as the overhead freight to Buffalo and Rochester.

The Chesapeake & Ohio Railroad gained ownership of the B&O in 1961 and the two railroads, along with the affiliated Western Maryland, became the Chessie System in 1973. The Chessie System merged into CSX Transportation in 1987 which quickly began to spin off its unprofitable lines. The first to go on the BR&P was the Rochester branch, which was sold to Genesee & Wyoming subsidiary company Rochester & Southern by the end of that same year. The rest of the BR&P followed when it was sold to the Buffalo & Pittsburgh in 1988, which, as a result, effectively recreated the BR&P into the modern regional railroad line that it is today.

Following the B&P's purchase of the BR&P's tracks from CSX, tracks on the north end of the line were slowly torn up with a majority of the Rochester side abandoned in 1991. Trains to Buffalo shifted to trackage rights on the former Pennsylvania Railroad north of Machias Junction beginning in 1997. Despite tracks being sold to the Buffalo & Pittsburgh Railroad (G&W), the BR&P name itself was not included in the sale. Even with all of the mergers that had taken place throughout the years, the BR&P continued to exist as a corporation on paper with the B&O and its successors owning the majority of its stock.

The BR&P continued to exist on paper even under CSX ownership because there were still shareholdings with a minority interest in the company. By 2013, only one BR&P stockholder remained with his holdings amounting to just one single share of BR&P common stock. This stockholder, known as Walston Hill Brown, was an investor in the BR&P but had died in 1928 before he could cash in on the B&O's $100 per share offer in 1932. This means that throughout the years, while all other outstanding stock was acquired and owned by the B&O, Brown's estate was the only minority owner. By this point, with its reporting requirements and administrative costs, CSX made the decision to relieve itself of the burden of maintaining the BR&P name.

Under the Abandoned & Unclaimed Property Act in the state of Pennsylvania, CSX received permission to make payment to Pennsylvania's Bureau of Unclaimed Property in lieu of purchasing the one share of BR&P stock that was owned by Walston Brown. CSX embarked on a search for any heirs or beneficiaries of Brown's estate but none could be located. With no heir or beneficiaries to be found, CSX arranged for the State of Pennsylvania to receive payment for the singular share of BR&P stock. The last remaining BR&P share of stock was valued at $874 in May 2013, and payment was promptly sent to the Bureau of Unclaimed Property. With this transaction completed, CSX became the sole owner of the BR&P and absorbed the company officially.

A few months later in October 2013, the directors of CSX approved the merger agreement for the BR&P to be absorbed into CSX. The directors of BR&P approved the agreement as well and it was filed with the Surface Transportation Board in November.

Since the Safety Transportation Board had no objections to the merger, the merger took place on December 21, 2013. The final chapter of the Buffalo, Rochester & Pittsburgh Railroad's 125-year history had come to an end. While the days of the route of "Safety & Service" have passed, the G&W painted EMD's of the Buffalo & Pittsburgh Railroad continue to transport large amounts of freight on the former BR&P that is still being guarded by the B&O signals.

Buffalo & Pittsburgh Railroad company logo.

Opposite above: The B&P BF-2 local arrives in Arcade, New York, to interchange freight traffic with the Arcade & Attica Railroad as well as service a customer situated at Arcade Junction.

Opposite below: A loaded coke train with a trio of SD60s slowly navigates Norfolk Southern's Ebenezer Secondary on the final stretch of its journey to Buffalo.

A southbound SIRI crosses the state line into Pennsylvania with a trio of SD60s leading the long manifest freight into Bradford.

A northbound extra billet train races through Ashford where the tower and a pair of turned B&O CPLs still guard the junction.

Approaching CP Draw in Buffalo, the BF-2 local slowly passes the Honeywell facility with SW1500 no. 1510 on the point.

An extra billet train arrives into Buffalo with an all EMD trio leading the way.

On the approach to CP Draw, the BF-2 local slowly passes the Powerhouse venue and event building.

A northbound RISI winds its way through Lewis Run with SD50 no. 5019 leading six other EMD diesel units with a long manifest freight in tow.

With SD60M no. 3892 on the point, a southbound SIRI races through the junction in Mount Jewitt, Pennsylvania.

After fighting the uphill grades out of Buffalo, B&P GP18s 887 and 926 pick up speed as they continue their southbound journey to Arcade on the BF-2 local job.

A trio of SW1500s slowly enter the B&P's Tifft Street yard with a long freight consist in tow.

An extra billet train waits for permission to proceed onto Norfolk Southern's tracks for the final stretch of the journey to Buffalo.

The BF-2 local waits for clearance and track authority at sunset in East Seneca.

A northbound extra billet train passes through the popular photo location known as Bird Swamp.

A yard job with a pair of B&P GP38-2s works the yard in Johnsonburg, Pennsylvania.

Rounding the bend on the Ebenezer Secondary, an extra billet train slowly approaches CP Draw in Buffalo.

With the last-minute snowfall partially covering the ground in Wales on a cold morning in April, B&P GP18s 887 and 926 lead the BF-2 Local southbound.

An extra billet train slowly rolls through Machias Junction where the former Pennsylvania Railroad signals that once guarded the junction are still standing.

B&P GP18 no. 926 leads a northbound BF-2 past the Mullican Flooring sign in Holland.

A northbound RISI with seven EMD diesel units races across the swamps in Cyclone, Pennsylvania.

84

After departing Bradford, a southbound SIRI with three SD60s battle the uphill grade at Drony.

The uphill battle for southbound B&P trains begins outside of Bradford at Lewis Run.

B&P SD50 no. 5019 and six other EMD diesel units roar through Mount Jewitt while passing by a B&O bracket signal.

A B&P yard job slowly shoves a line of tank cars and a covered hopper car back across CP Draw in Buffalo.

B&P GP9 no. 203 sits quietly in a siding in Salamanca.

B&P GP18 no. 926 idles in East Seneca at sunset.

5

THE DEPEW, LANCASTER & WESTERN RAILROAD:
GVT's Peanut Line

The Depew Lancaster & Western Railroad, like the Falls Road Railroad, is a subsidiary short line railroad company owned by Genesee Valley Transportation. Operating two divisions out of Batavia and Lancaster, the DL&W keeps itself busy servicing the customers along their industrial tracks and interchanging their traffic with CSX (Batavia) and Norfolk Southern (Lancaster). The Batavia division operates on approximately 5 miles of track that once was a part of the Lehigh Valley and the New York Central's Peanut Line as well as their respective mainlines.

Starting from the interchange with CSX (former Conrail mainline), the DL&W occupies the former Conrail Attica Industrial Track, which runs through the center of Batavia. The DL&W also utilizes operating rights on 4 miles of the modern CSX mainline from their yard in Batavia to CP402 in order to access the Batavia industrial and running tracks that was once part of the Lehigh Valley's mainline. The Lancaster Division of the Depew Lancaster & Western is an approximately 3-mile-long remnant of the Delaware Lackawanna & Western Railroad's mainline, which was not included in Conrail's official formation in 1976. This section of track was purchased by the Erie County Industrial Development Agency and was operated by Conrail until 1988. The Depew Lancaster & Western was designated to operate the line starting the following summer in 1989, six years after the railroad purchased the Batavia division from Conrail in 1983. The DL&W's freight traffic on the Batavia division is handled by ALCO S-6 diesel switcher no. 1044 with MLW RS-18 no. 1801 acting as the backup locomotive.

The Depew Lancaster & Western traces their roots back to the days of the New York Central's Batavia Branch, also known as the "Peanut Line." The Peanut Line began as the Canandaigua & Niagara Falls Railroad in 1850 when it was incorporated under new general incorporation laws for railroads that were being passed by the state legislature at the time. These new laws made it easy for railroad promoters to create new railroad lines. Unfortunately, a significant majority of these new railroad lines fell due to financial trouble, and the Canandaigua & Niagara Falls Railroad became part of the New York Central in 1858.

In the early 1850s, the Erie Railroad and the New York Central were competing with one another and were in the process of opening up train traffic to Buffalo and the Great Lakes region. On top of that, bridge builder, John A. Roebling, was in the process of building a suspension bridge across the Niagara River to Niagara Falls. Through this new bridge, rail connections would be opened up to Detroit, Chicago, and other points west. A meeting was held in Lima in March 1851 in order to organize the Canandaigua & Niagara Falls Railroad. During this meeting, corporate officers were elected and stock was sold to provide funding for construction planned between Canandaigua and the bridge at Niagara Falls. The C&NF was completed between Canandaigua to Batavia by January 1853 with the first passenger trains operating to North Tonawanda in July of that same year.

The C&NF was completed the following spring, in April 1854, with the full route being just under 99 miles long and freight and passenger traffic booming almost immediately after completion. While the freight hauling rates were very competitive, it was not enough to sustain the needs of the C&NF. The railroad failed to pay its bondholders twice in 1857 and was quickly foreclosed and sold at auction at the Ontario County Court House. The railroad was then quickly reorganized as the Niagara Bridge & Canandaigua Railroad in 1858 before being leased to the New York Central. By 1890, the New York Central had purchased most shares of the NB&CRR's stock which allowed the railroad to merge with the New York Central. The city of Batavia became a division point on the New York Central mainline starting in the early twentieth century, and the line from Canandaigua to Batavia officially became the Batavia Branch while the line from Batavia to North Tonawanda became the Tonawanda branch. For a brief period of time, these two branch lines were referred to as the East Peanut and West Peanut.

While the origin of the Peanut Line's name is not entirely known, the most notable evidence comes from a news article in the Ontario County Times that was published in March 1906. In the article, Walter L. Richmond, grandson of former New York Central President Dean Richmond, reminisced about the name of the Peanut Line. Walter Richmond stated that his grandfather, Dean Richmond, "was responsible for

the Canandaigua and Tonawanda branches of the Central being dubbed the 'Peanut Road.'" To quote Mr. Richmond:

> It was the time the branches were being built, and there was also a construction gang at work on the mainline. One day the men on the main line struck, and in a few days afterwards the gang on the branches followed suit. The first strike seemed to create a lot of anxiety among the officials of the road, of which Dean Richmond was then president, When Mr. Richmond was informed of the second strike, he remarked: "Oh, that's only a little peanut line, anyway." The name has since stuck to the branch.

After thriving through the second half of the 1800s, the Peanut Line began to decline in the 1920s. As the roads and automobiles took over the transportation world, traffic on the railroad decreased dramatically as a result. Freight traffic would end on the West Peanut in 1939 with the Canandaigua to Holcomb section following suit later in 1972. By the 1970s, the tracks were in such terrible condition that train crews refused to ride across the Mud Creek trestle in fear for their own safety. In order to get around this, the crews would allow the train to cross the trestle unmanned at a very slow speed. Once the train was across the trestle, they would climb back aboard their train on the other side. The Peanut Line had become a dying shell of its former self from decades prior.

Today, only small remnants of the Peanut Line remain. Since the 1970s, Mother Nature has been gradually reclaiming the abandoned right of way as most of the tracks were removed in 1979. Also, parts of the Peanut Line as well as the former New York Central mainline now serve as the Depew Lancaster & Western's industrial tracks that serve multiple industrial customers in urban Batavia. The DL&W's freight traffic on the former New York Central right of way consists of paper products, recycled materials, lumber, grain, aggregates, plastics, and agricultural products. The Batavia division operates on a weekday basis while the Lancaster division operates as needed. With a lot of industrial customers to serve on the small amount of track that they operate on, the DL&W is a unique opportunity to see an industrial switching railroad navigate the streets and buildings that the New York Central once had a large variety of passenger and freight trains thundering through the center of town to points east and west.

The Depew, Lancaster & Western Railroad's company logo is proudly displayed from the side of no. 1801's cab.

DL&W RS-18 no. 1801 brings a cut of empty scrap cars to be loaded outside of the railroad's transload facility in Batavia.

Genesee Valley Transportation has multiple 3T transload service locations in New York State. Such locations include Batavia, Brockport, Buffalo, Lockport, Medina, Rome, Utica, and Carthage.

DL&W Alco S-6 diesel switcher no. 1044 leads a pair of boxcars through urban Batavia to be dropped off at Georgia Pacific.

No. 1044 works the sidings outside of the railroad's transload facility in Batavia.

No. 1801 shoves the empty scrap cars into their designated siding to be loaded with scrap at a later date.

No. 1044 finishes switching freight cars between Swan Street and Harvester Avenue.

No. 1044 crosses the Tonawanda Creek via the double track steel bridge that was once part of the New York Central's Peanut Line.

The DL&W crew begins their day after bringing no. 1801 out of the railroad's engine house.

No. 1044 begins its return journey after making a routine drop off at Georgia Pacific.

No. 1801 rounds the bend at Georgia Pacific after picking up five scrap cars from the railroad's interchange with CSX.

95

BIBLIOGRAPHY

"About Us," *New York & Lake Erie Railroad*, nylerailroad.com/about-us/.

Buffalo Cattaraugus & Jamestown Scenic Railway, bcjrailroad.com/history/.

Buffalo Southern Railroad, buffalosouthernrr.com/.

Burns, A., "Arcade & Attica Railroad Corporation," *American Rails*, March 11, 2022, american-rails.com/arcade-attica.html.

Conrail, conrail.com/about-conrail/history/.

"End of the Line for the BR&P Railway," pp. 4–15 klnl.org/magazine/kll173brp.pdf

"Erie Canal," *History.com*, A&E Television Networks, March 15, 2018, history.com/topics/landmarks/erie-canal.

Everts, D., "Celebrating 30 years since 'The Natural,'" *The Salamanca Press*, September 5, 2013, salamancapress.com/news/celebrating-30-years-since-the-natural/article_697519d2-14af-11e3-947a-001a4bcf887a.html.

"Gowanda Rail's Update from Abandoned to Efficient," *Observer*, June 13, 2018, observertoday.com/life/community-news/2018/06/gowanda-rails-update-from-abandoned-to-efficient/.

Greenwood, Marcia. "Thanksgiving movie 'Planes, Trains and Automobiles' filmed in NY: Behind the scenes," *Democrat & Chronicle*, November 22, 2021, democratandchronicle.com/story/news/2021/11/22/planes-trains-and-automobiles-thanksgiving-movie-filmed-batavia-ny/8584527002/.

Our History, aarailroad.com/our-history/.

Palmer, R., "The 'Pennsy' and the 'Peanut Line,'" *The Crooked Lake Review*, May 5, 2016, crookedlakereview.blogspot.com/2016/05/the-pennsy-and-peanut-line.html.

Pierce, P., "Canandaigua history: Remembering the old Peanut Line," *Daily Messenger*, April 24, 2021, mpnnow.com/story/news/2021/04/24/ontario-county-historian-preston-pierce-remembering-old-peanut-line/7259023002/.

Sheret, J. G., "The 'Peanut Line' of the New York Central Railroad," *The Crooked Lake Review*, 2007, crookedlakereview.com/articles/136_150/142springsummer2007/142sheret.html.

"Todd's Railfan Guide to Batavia NY," *Railfan Guides of the U.S.*, January 9, 2021, railfanguides.us/ny/batavia/index.htm

Wilson, L., "Depew Lancaster & Western Railroad," *The Greater Rochester Railfan Page*, February 20, 2005, rochester-railfan.net/dlwr.htm.

Wilson, L., "Falls Road Railroad," *The Greater Rochester Railfan Page*, February 20, 2005, rochester-railfan.net/frrr.htm.